CONTENTS

INTRODUCTION 5

1 DIVERSITY AS A VIRTUE 9

2 ART AND INDUSTRY 27

3 THE PROBLEMS OF MODERNISM 47

4 UTILITY AND AFTER 71

5 CHANGING LIFESTYLES 85

6 THE STATE OF THE ART 100

BIBLIOGRAPHY 108

GLOSSARY 109

ACKNOWLEDGEMENTS 110

INDEX 111

INTRODUCTION

THIS volume is one in a series on 20th century design and can be read either as a complete study in itself or as part of the whole series which aims to give a broad picture of the ways in which design has developed since 1900.

Ceramics, at its widest, is a term that includes everything made from clay – from building materials to bathroom fittings. Here, however, we are concerned only with domestic tableware, which forms a relatively coherent single subject and is an area of particular interest as it is such an essential part of our everyday life.

The emphasis here is on industrially produced tableware. This is because, while the individual 'craft' ceramics of various countries, including Europe and the United States, have been widely studied, the more recent work of the factory designers has been less well covered. I hope that this book will go some way towards filling the gap.

It is also true that the existing literature on ceramics tends to concentrate on periods before 1900. This is because collectors, who have formed part of the prime readership for such books, have been principally interested in 'antiques' whose age and scarcity are part of their charm. Pieces from the 20th century have not, until recently, been regarded by the purists as having the same values as the earlier works.

Things are changing however, and now even the most prestigious auction houses are finding that work by known designers of the 20s and 30s is fetching very high prices. There have also been exhibitions staged about specific people or factories, and the catalogues to these have added useful information to the available literature on ceramics.

One disadvantage, however, of these biographical studies is that they can have the effect of isolating an individual designer and suggesting that his or her problems (and solutions) were unique. In fact, designers, particularly in industry, never work in isolation and are always influenced by the circumstances surrounding them. Their ideas are usually therefore very much a part of a general debate or feeling about design prevalent at the time they are working. It is one of the aims of this book to look at the broader context in which ceramic designers throughout this century were producing their ideas, as well as at the particular designers themselves. The fact that design is often a collaborative process is another reason why it is important not to limit the discussion to the work of specific known designers, but to look more widely at the background to the creation of trends and innovations.

Design in industry is a very topical issue at the moment, and one of obvious relevance to design students. Dealing with recent history is of course fraught with dangers and inevitably somewhat speculative. However, I hope that this study, by looking analytically at the recent background to industrial design in tableware, will be helpful to students with a practical as well as a general historical interest in the subject.

Retrospective studies are of course always coloured by the author's own historical perspective on the subject matter. In the field of design, however, we also have access to statements of some of the perspectives of the people involved at the time. It is important to know how the

manufacturers and designers themselves saw their own positions and the traditions within which they were working. With this in mind I have included as rich a variety as possible of actual quotations giving examples of 'first hand' thoughts and opinions during the period in question. The sources are given in the text rather than in footnotes, and a list of the main books and journals can be found in the bibliography for those who might want to follow them further or to go into the subject in greater depth.

The book is roughly chronological in structure, and the chapters are divided into periods that are suggested by the subject matter itself. The starting point for the study is the British ceramics industry, but ideas about design both on the part of the theorists and the manufacturers need essentially to be seen in an international context. In particular this book considers the differences and interactions between the American and the European ceramics industries throughout this century.

Sources for design study are varied and scattered. The first source in this instance is of course the ceramic pieces themselves. Examples from earlier periods, especially those which can be attributed to major factories, can be found in many museums, both national and local. Fewer pieces of the 20th century have yet gained that status, despite the claims of some national museums that they want to show contemporary industrial design. The museum collections of some of the larger factories themselves are often more interesting because they can show not only examples of the finished work but also pattern books and catalogues which help describe some of the preliminary stages. Besides these more formal sources the majority of pieces can still be found in kitchen cupboards and junk shops – especially if you are interested in them not only for their potential value as collector's items but as historical evidence.

Trade journals are useful repositories of information, for while their commercial and advertising function has to be adequately recognized, they do cover many aspects of lower grade ware which never makes the museum collections. They also show what the makers of this pottery felt about the state of the industry and issues connected with it, which is of as much importance as the more widely known theories of critics and avant garde designers. From this sort of evidence it is possible to start assessing why at some moments the critics could and did influence ideas about design and why at others they were completely ignored.

One of the problems with studying isolated objects as seen in museum cases or bought in antique shops is that they have been taken out of the context to which they belong. The question of design has to be studied not in isolation, but in the light of the desires and expectations of the owner of the piece. How a particular dish would be used, what part it was going to play in the household meals and how it would fit in with other objects in the home all affected how it should look. This essential background information, however, is a kind of 'common knowledge' – it is not recorded or collected and is thus difficult to pin down after the event. It is possible by looking at contemporary illustrations, reading recollec-

tions etc., to get some sense of how an object was thought about and used by its owners, but this judgement can rarely be positive. Illustrations, even home snapshots, were generally taken for a purpose and so posed or tidied up. Information given in home journals and women's magazines shows us some of the advice given to housewives on choosing their tableware, but it is not a guarantee that the advice was taken!

Nevertheless, by piecing together some of these sources, this book hopes to put forward an account of why ceramic design has taken some of the forms it has over the 20th century – and if it succeeds in giving some insights to people whose interest might have begun with just a few pieces, then it has served its purpose. For readers who are actively engaged in designing I hope that this account will throw some light on the nature of the activity and the industry in which they are involved.

In writing about a quite long period of history and covering such a wide field I have had, inevitably, to use a high degree of selection. It is very much to be hoped that more books and alternate views will continue to appear, as the subject is one that deserves to go on being broadened and extended in many directions.

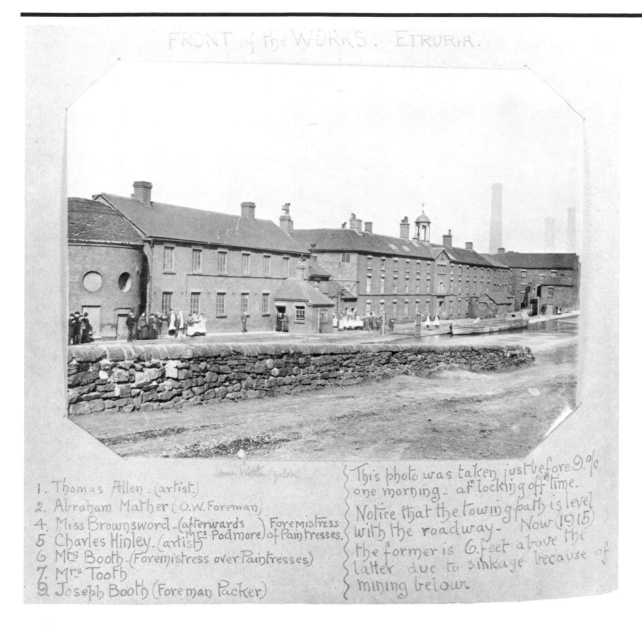

1. Thomas Allen - (artist.)
2. Abraham Mather (O.W. Foreman)
4. Miss Brownsword - (afterwards Mrs Podmore) Foremistress of Paintresses.
5 Charles Hinley. (artist)
6 Mrs Booth - (Foremistress over Paintresses)
7. Mrs Tooth
9. Joseph Booth (Foreman Packer)

This photo was taken just before 9.% one morning - at "locking off" time.
Notice that the towing path is level with the roadway - Now (1915) the former is 6 feet above the latter due to sinkage because of mining below.

Photograph of Wedgwood's Etruria manufactory as it appeared in 1898, taken from a scrapbook compiled by Harry Barnard in 1898. Barnard was a modeller, designer, Wedgwood historian and curator during the late 19th century and continued to work for Wedgwood until his death in 1933.

DIVERSITY AS A VIRTUE

THE major sources for the study of ceramics at the turn of the 20th century – museum collections, antique shops, company archives, books and magazines – represent only a small proportion of what was actually made, but even so the first impression they give is of an immense variety of shapes and patterns. From the finest bone china dinner service to the cheapest earthenware plate, there is more diversity of shape and decoration in 1900 than we would expect to find even in a specialist china shop today.

To understand why this was and how thinking about design has changed, we need to look at the structure of the industry at the time and the factories producing the ware. The attitudes to design which created this variety came in part from the many techniques and practices which the industry had developed over a long period of time, and in part from conscious decisions taken by heads of firms who had just been experiencing an uncertain period of trade.

In Britain in the 1890s, the pottery industry consisted of numerous small firms. Many of these were centred around the area of North Staffordshire, known as 'The Potteries'. They had grown up in that location originally because of the good supplies of local clays and coal, but they remained strong in that region even when materials imported from other parts of the country began to be used, because by then they had a more than adequate supply of skilled labour. Besides this main centre however, there were a number of firms in other sections of the country, especially those who used other types of clay bodies than earthenware or china, such as the stoneware potteries of London and Derbyshire, and the porcelain producers in Derby and Worcester.

It was in the Potteries however, that the process of industrialization began. This established the techniques, working practices and the organization in certain firms which gradually set the pattern for the industry as a whole. This process of change from the small unit operated by a master potter and apprentices to the organized factory with its regulated labour force happened over a period of time in the early 18th century. Its progress, however, was marked by Josiah Wedgwood's opening on the 13th of June 1767 of his 'model' factory Etruria. This was for the production of his developing range of ornamental ware and was the first example in the Potteries of the factory system. This was typified by the rationalization of space and processes to produce a through-flow of ware from one end to the other, and the division of labour to exploit specialist skills in each stage of the making. Similarly, when in 1770 Josiah Spode took over the Bankes Works in Stoke, he extended and

reorganized it to accommodate the increasing demand for his blue-printed earthenware.

While these changes were initially undertaken by a few of the more entrepreneurial manufacturers and many smaller works continued to exist as before, owned and operated by the master-craftsman aided mainly by members of the family, it is significant that from about 1780 onwards in contemporary books and inventories, the term 'potworks' begins to be superceded by the word 'manufactory'. In Britain the development of banking facilities allowed heads of private firms to make these changes, either by borrowing the fairly modest capital investment needed or by taking on a 'sleeping-partner'. The organization often remained within a single family with all members involved, and this family firm remained the basic unit of the industry up until the 20th century. They were potteries which were run privately and had to compete in the market place. In this respect they were very different from the early factories in the rest of Europe where attempts to imitate the then-fashionable Chinese porcelains had led to the establishment of works such as Meissen, Vincennes and Sèvres under Royal patronage. The advantage for these latter was that they could rely on state subsidies while undertaking research. It also meant that their designs were almost all for the aristocratic market and so their prices could be less competitive, while more time was taken over the often very elaborate patterns.

The advantages of the factory system with its division of labour were apparent not only to Josiah Wedgwood. As early as 1701 they had been recognized with regard to other manufactures such as textiles. Henry Martyn in his tract *Considerations of the East India Trade* pointed out that any maker of any individual part, *"must needs be more skilled and expeditious at his proper business, which shall be his whole and constant employment, than any man can be at the same work whose skill shall be pusled and confounded with a variety of other business."*

To ensure a profit, the British firms had to increase production and also extend their markets. The first of these needs led to experiments with the application of steam power. There is still some doubt as to the exact date for the introduction of the steam engine into the Potteries. John Turner installed what was probably a Newcomen engine in 1775 – he and Wedgwood had visited Cornwall where these were used in the mines. Josiah Spode also purchased one for the Bankes Works in 1784.

At first these engines were used to pump water upwards and over a water-wheel, the wheel then supplying power to the grinding pans. The preparation of raw materials, grinding of flints etc. had previously been undertaken by wind- or water-mills, and the first application of steam power was merely to facilitate this process. It was not until the reciprocal motion of the pumping engine was converted to a rotary motion by Boulton and Watt, that steam power could be used directly by the clay mills and the grinding pans.

It was during the 19th century that further steps were taken to mechanize the production of pottery. These were to have implications both for the workers in the industry and for the actual design of the pieces. The first step was to apply machine power to the actual making processes, to turn both lathes and throwing wheels. The use of moving belts to transmit power to a series of wheels throughout the factory was described in the *Potter's Examiner and Workman's Advocate* by William Evans in 1834, by when the practice was already well established.

Where steam power was applied to the flat-ware and holloware pressers' wheels, it was only a modification to the turning process and at first was well received by the pressers as it increased their possible earnings which were paid by piece rates. However the rates were very quickly re-set to take this into account. It was the threatened introduction of 'jiggering'

Illustration representing potters in the late 18th century, using kick-wheels for both throwing and turning before the introduction of machine power.

and 'jolleying' machines which aroused the opposition of the workers in the mid 19th century. These were seen as a threat to jobs rather than as aids to skilled processes. They actually mechanized the process of forming the clay in the moulds by the use of mounted metal profiles which only had to be lowered on their arms to press the clay against the mould. It greatly speeded up the production but could mean less workmen were needed. It was also feared that, as the machines required less skill and strength, women would be employed to use them because they could be paid lower wages.

Although action by the union delayed the widespread introduction of these machines, their use increased during the 1860s, and in the 1870s the slump in trade and unemployment in the potteries reduced the union's power. After 1870 they became well established and remained the basis for most flat- and hollo-ware making until 1945. Although these machines represented a degree of de-skilling, even these, like the processes of mould-making and decorating, still relied on a supply of skilled labour. By the end of the century it was assumed by both managers and workforce that this was as far as mechanization could go and the processes involved in using the machines had become accepted as traditional.

The effect of this industrialization on the products was two-fold. First, when the making was divided up between workers, a conceptual 'design' was necessary for operatives at each stage to work to in order to achieve the desired end result. The designs could no longer come from the traditional knowledge and creative skills of one maker and so had to be conceived as a separate stage in the factory process, requiring its own skills.

The role of the 'designer' was often taken by the manufacturer who, in the first generation of factory owners, was frequently a master potter in his own right. Subsequent generations were more concerned with business management and, while retaining the overall decision making themselves, delegated the actual creative process to someone else within the works. Josiah Wedgwood employed artists better known for their work in the fine arts to design for his ornamental ware, where a knowledge of sources and the prevailing fashions of

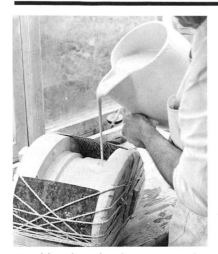

Mould making for slip-casting – the liquid plaster is being poured around the model to complete the mould. The lugs or 'natches' can be seen which locate the finished pieces when the mould is being used.

the late 18th century were necessary. Smaller manufacturers relied to a large extent on copying other popular designs and on adapting from the increasing number of pattern books available. Design became less dependent on a knowledge of clays and glazes and more on draftsmanship.

This was certainly true where surface decoration was concerned. A semi-mechanical process was developed whereby printed designs on transfers could be produced which were used to decorate both earthenware and china. Wedgwood used Sadler and Green in Liverpool in the 18th century and the Worcester Porcelain factory also pioneered this technique within their factory. It rapidly encouraged the dependence on graphic forms such as prints and book illustrations, and manufacturers borrowed freely from these sources. During the 19th century the engraving department was an essential part of most large firms, while free-lance transfer printers supplied the smaller ones.

The second important implication of industrialization was the effect that mechanical production had on the ware itself. Although wheels, lathes and moulds had been in use to make pottery for numerous years, the somewhat rule-of-thumb methods of preparing clays and glazes and controlling the firing of ware produced variations in shape and texture. At Wedgwood, the production of creamware at Etruria was based on standardization of shapes and bodies, not only because it increased output but because of a growing desire for scientific accuracy. Precision was becoming a value in itself. He worked to produce a high degree of consistency. As he and the other 18th century manufacturers extended their markets, and skillful salesmanship made pottery an acceptable material for tableware which could compete with pewter and silver, so the public's expectations of ceramics changed. The kinds of values associated with mechanical production – simplified outlines, identical sets of forms, consistency in pattern and colour – came to be the norm and the number of potteries totally dependent on craft skills declined.

With the further mechanization of processes in the 19th century, it became possible to reproduce the sort of very elaborate work that was made by the subsidized factories in Europe, especially France. The use of slip-casting, where liquid clay was poured into a plaster mould, was facilitated by the discovery of de-flocculating agents in the 19th century. These allowed the liquid slip to be made with less water and so speeded up the use of the moulds which had formerly had to dry out for long periods. The more extensive use of moulds encouraged elaboration of surface decoration and modelling. It was possible to reproduce complex work which had previously involved a lot of expensive hand-work and only been available to the rich.

The simplification introduced with the earliest factory system, now gave way to more complex and ornate designs. This was in response to a growing desire among the consumers to emulate goods that had formerly belonged only to the few.

Another factor which became increasingly important to many manufacturers throughout the century, was the question of overseas trade. The numerous different

Wedgwood creamware plates and the first pattern book of border designs showing corresponding designs. The first pattern book covers the period from 1769-1814.

A finished, fully detailed pencil drawing made for subsequent engraving onto a copper plate for the printing of transfers. The white space on the rim is carefully calculated to take account of the tilt of the plate's rim. The drawing took 24 hours to complete and the engraving would take six weeks. This drawing was made by Philip Robinson for Crown Derby which was still using these types of design in 1955.

attempts to imitate Chinese porcelain, which had such an influence on the West from the 17th century onwards, gives an indication of the importance of international relationships in the history of ceramics. Since then, not only have the products of other countries been looked to for technical and stylistic innovations, but the international trade in pottery has had a considerable effect on design.

From its inception in 1877, *The Pottery Gazette and Glass Trades Review* devoted space in its columns to news of pottery manufacture in most areas of Europe and particularly to the American trade. In Pittsburg, *The Pottery and Glassware Reporter* fulfilled a similar role on the other side of the Atlantic.

Since the 18th century, when Wedgwood had deliberately set out to expand his markets across the Atlantic, a considerable part of Staffordshire's trade lay in America. The proportion of output exported overseas for a relatively small manufacturing industry was extremely high. Initially most of the trade was into America, but already during the 19th century the United States was developing its own home industry. From 1869, the Americans established a Consulate, which was at first in Tunstall – one of the Potteries' five towns – but later moved to Stoke itself. The job of the Consul was not only to facilitate American imports

from the area but to compile reports on conditions, wages and comparisons of techniques which would be of value to his home country. The American Consul was withdrawn in the 1930s when it was decided that for economic reasons the Potteries could come under the larger brief of the Consul in Birmingham, who could cover the whole West Midlands manufacturing area.

Ironically, the trading slump of 1874 – 1879 (the first of a series) which was in part caused by the American Civil War and the period of re-construction after it, produced the severe unemployment in Staffordshire which led many potters to emigrate to the United States. Their contributions to the existing industry increased competition for the American market. Nevertheless, the fortunes of many British pottery firms were based on the production and export of earthenware and particularly, 'ironstone' to America.

An elaborately shaped earthenware fruit dish decorated with transfer prints in blue and white. Staffordshire, early 1840s. The pattern consists of Arctic scenes and, in the panels, wild animals, possibly based on Bewick's animal illustrations.

Like the British, the American pottery industry was based on private capital and ownership of firms. These firms produced large quantities of fairly plain ware for domestic use while most of the more elaborate high-grade wares were imported.

Potteries producing porcelain had been established in America in Massachusetts and Philadelphia between 1760 and 1850. These included the short-lived Bonnin & Morris firm in Philadelphia (1769-71) and the Jersey Porcelain & Earthenware Company of Jersey City (1823-1825). The Tucker family firm in Philadelphia was the first commercially successful porcelain firm (1825-38). Its designs were based on French and English models. But the basis of American production on a large scale was the making of china and a hard earthenware often called semi-porcelain or granite ware. This was made mainly around New Jersey using ball-clays and china clay imported from Britain. The major development was in the last 30 years of the 19th century.

Lenox began to make china in 1889 in Trenton, but New Jersey was beginning to be overtaken in importance by the Eastern Ohio and Western Virginia region as the discovery of rich clay deposits and coal stopped

Two transfer printed plates of the late 19th century. The whiteware plates were exported to the US were they were decorated in New York with designs taken from topical prints.

the need to rely on imported raw materials. The later finding of natural gas gave support to the area. America used gas for firing long before it was considered in most of Europe.

The Homer Laughlin China Co. started as a small works in East Liverpool, Ohio, in 1871, while the Sebring brothers began with one small pottery in East Liverpool in 1887 and rapidly acquired others. Another famous firm founded in the 1880s was the Onandaga Pottery Co., makers of Syracuse china.

Whereas the production of whiteware on a limited scale posed no serious threat in itself to European manufacturers, the protective tariffs on imports during the 70s and 80s made a valuable space for the increase of home production. The fact that these factories based their production on large quantities of limited shapes and the acceptance by the consumer of undecorated ware for ordinary use, made it easier for them to use mass-manufacturing techniques right from the start.

In contrast, the British manufacturers who accepted as standard fairly labour intensive practices and who, for the most part, were politically committed to Free Trade and decried protectionism, believed that the only way to compete between many small firms was to produce an ever wider range of different shapes and patterns. American manufacturers mostly produced wares for stock, which they continued to produce even over slack periods of demand. British manufacturers, on the other hand, produced to fulfill orders, which meant it was much more difficult to plan rationalized production and any drop in trading had an immediate effect on the workforce.

Britain was not the only country which looked to a worldwide market for its ceramics. The export trade in porcelain from China had been extensive in North America and some of the European producers also saw it as a major market. The French obviously had close cultural and economic ties with their former colonies in North America and the American preference for a hard, very white-bodied ware favoured the use of Continental hard-paste porcelains. Political events could very directly effect the trade with one country or another. During the American War of Independence in the 18th century British pottery was deliberately boycotted and French pots were bought instead.

By the last quarter of the 19th century the older continental porcelain firms had ceased to have the patronage and subsidies enjoyed at their foundation. Those that had survived the collapse of the absolutist monarchies had had to re-organize and compete commercially. Even those where local government or state ownership was substituted were made to be more competitive. The growth of free enterprise also produced many more smaller companies designing goods for the growing middle range markets, not just for the aristocracy.

The famous porcelain factory of Meissen, which had been the property of the Crown, was declared in 1831 the property of the State. The factory then attempted to reduce the cost of its ware to appeal to new markets. It was only at this time that a firing was changed to use coal instead of wood. They also began research into alternative methods for some of the most expensive processes. The use of liquid gold was developed which was a cheaper form of gilding as it fired bright and did not require the time-consuming labour of burnishing. This technique was quickly taken up and used extensively by other smaller factories, including many in Britain, and used to facilitate the production of cheap ware in imitation of much grander effects.

The use of the new gilding, the bright, flat colours adopted and the cruder forms of modelling which allowed for much faster making did restore the viability of the Meissen factory. However, when they were quickly copied by others, they gave German porcelain the reputation it had before the First World War of being cheap and garish.

After the London Exhibition of

1862, the administrative board of Meissen had a chance to assess their progress towards rehabilitation and noted that, *"the Royal factory is able to stand the competition of the German and French factories in every respect, but that the English china industry has progressed with such giant strides that its rivalry could not be left unnoticed."*

Nevertheless, Meissen's policy of broadening its market by such techniques tided it through, until the aspiring middle-classes brought about a revival of interest in the elaborate Rococo forms for which the company had originally been famous. After the war of 1870-71 increasing quantities were exported to America and they continued to be until the First World War.

In the 1870s both Sèvres and Berlin also made moves to reform their production and shapes were simplified to eliminate a lot of costly assemblage of parts. To reduce firing costs a softer body which fired at a lower temperature was introduced. Sèvres had ceased to make its original soft-paste porcelain in the early years of the 19th century and Berlin had always used hard-paste. These softer bodies could take a much wider range of colours and were mainly used for decorative ware while the very dense white harder body continued to be used for tableware. In Vienna, the porcelain factory had been taken over and run as a State enterprise but it could not overcome its financial difficulties and closed in 1864.

The difficulties that most factories seemed to be experiencing during the 1870s prompted them to re-assess their output and markets. While in some cases this seemed to demand rationalization and simplification of production costs, the common understanding was that the main need was to appeal to the growing middle class market. The values and self-image of this sector were different from the aristocratic traditions in design upon which the factories' original products were based, though, as Meissen found, the traditional designs could be re-worked to fit with the aspirations of the new breed of consumer.

The expendable income of urban middle-class households in the late 19th century permitted an increasing consumption of goods. Types of objects proliferated and gadgets abounded. The home was becoming the centre of attention, with an increasing polarization between home and work. The image of the woman as wife and mother and essentially as 'home-maker' was being stressed. Mealtimes — obviously the events where tableware was to be used — were rituals at which the relationships of the family were reinforced. The degree of formality depended on the time of day and the members who were present. The questions of whether there were outsiders, how the courses were arranged, the types of food served, who presided and the order in which people were served were all extremely important. Similarly the tableware and accessories were props in this performance. Their shapes, decoration, degrees of elaboration and imagery were chosen, albeit subconsciously, to confirm the family's belief in itself and its position. Newly created wealth needed to be expressed in material form and, above all, volume. Pottery, whether tableware or ornamental was not just functional in a utilitarian sense. It had to say the right things.

Even in Britain, despite the long-standing commercial base that existed, some of the older firms had to adapt to the new climate. For Wedgwood, the spare, precise 'machine-aesthetic' of Josiah's creamware was abandoned for brighter colouring, gilding — which originally was almost never used — and more complicated forms. In 1878, the production of bone china was again introduced. It had been tried not very successfully between 1812 and 1816. The London showrooms, a major feature of the 18th century Wedgwood's selling policy, were re-opened in 1875 to encourage sales.

A look at the wares of Minton's, founded in 1793, shows an increasing range of wares produced and the

increasing elaboration of forms. In the first half of the 19th century the majority of goods produced were functional ones, whereas by the 1880s they were renowned for their ornamental pieces.

Manufacturers believed that sales could only be increased by endorsing the idea that many different forms and designs of pottery were needed in each household. By trying to establish tableware as having very specialized functions, volume within each household could be increased.

In order to keep a very rapid flow of new designs on the market, the 'designer' role within the factory increased. In the larger firms the appointment of an Art Director became more common. The smaller ones simply widened the scope of their borrowed sources or resorted more often to the independent model-makers and transfer printers.

The emphasis on 'home-making' which is evident in the growing number of publications on household management and house-decoration in Victorian times, encouraged the embellishment of the domestic interior with objects which would uplift the moral sensibilities of the family. This accretion of objects, many of them fulfilling sentimental and didactic functions rather than utilitarian ones, can be seen in illustrations of rooms in the 1860s and 70s. But this climate which favoured the production of ornamental ware by factories, often to be sold as individual pieces, also favoured the establishment of alternative works producing goods on a small scale which could be sold as 'Art' wares.

The Great Exhibition at the Crystal Palace in 1851 had given rise to much criticism of the industrial products on show by those with an interest in reforming the quality of design. Some degree of concern had been expressed before that date but the exhibition, because it was a very public event, acted as a catalyst.

The *Art Journal* published by Henry Cole, an energetic civil servant and designer, was a mouthpiece for design reform. The ornateness which was perceived by the manufacturer as a necessary selling-point because it represented apparently time-consuming and traditional skills, was seen by Cole and others as the exemplification of inhumane modes of production and a concern with material wealth which was morally contemptible. The eclectic nature of the styles used, Rococo, Gothic and the Renaissance, were accused of being debased and shorn of their original meanings. In fact, it could be argued that to the consumer they represented just those conditions required, the stability of families with their roots in history and the power to exercise choice between virtually all the wealth of the past and the colonized world.

Cole was particularly critical of the use of Chinese sources for the designs on English ceramics, though these were perhaps some of the commonest. He declared them *"wretched imitations of the grotesque and unmeaning scenes represented on the porcelain of China."* 'Unmeaning' to Cole because they did not conform to the Western ideal of naturalism or Renaissance perspective and because they came from an unchristian culture. This was a view which the advocates of the aesthetic ideal were to reverse in the 1880s.

Henry Cole also claimed to believe in the supremacy of utilitarian function and the subservience to it of any form of decoration. It was because of this that he has been hailed as a forerunner of the ideas of modernism. Certainly this aspect of design as it evolved in the writings of John Ruskin and the work of Morris and the Arts and Crafts movement was to have an influence on the thinking of designers, critics and teachers for many generations.

Cole designed a tea set in 1845 in order to exemplify his ideas and in the hope of encouraging other artists to design for industry. For this he used the pseudonym Felix Summerley. He did his research in the British Museum and, through his friendship with Herbert Minton, had it made up by Minton's firm. His professed aim

was to use the best historical precedents (in this case Gothic, not Chinese) combined with the knowledge of manufacturing gained at Minton, to produce pieces combining utility and appropriate ornament, but with the latter subservient to the form. The set was put into mass-production by Minton but it must be said, that they had to adapt and simplify some of his forms to do so.

Designers who criticized the pieces on view in the 1851 Exhibition and at the later exhibition in 1862, failed to acknowledge the fact that many of them had been produced especially for exhibition purposes. They did not necessarily represent normal production. They were designed specifically to show the elaborate skills of modelling and decoration available within the factories and had a nationalistic significance. As *tours de force* they were set up to compete with the best skills of France and Germany and to make apparent their ability to do so. To judge from the comments of the Meissen board of directors, the point was taken.

Critics like William Morris however, rather than attempting to become involved initially in industrial design, blamed the system of the factory for the alienation of workers and the decline of pre-industrial craft skills. Their reaction was to establish workshops on a basis of the medieval craft guilds and to put renewed value on hand-crafted objects. Although Morris's professed aim was to enable a greater number of people to obtain such well-made goods, the economics of such a limited production meant that they quickly became valued for their exclusive qualities, as symbols that the purchaser had both the ability to buy at such prices and the discrimination to do so.

Morris did not immediately concern himself with ceramics, his work was mainly in textiles, wallpaper and furniture. In the early days of the firm the original Pre-Raphaelite members had produced some tiles, but in later commissions for interiors where tiles were needed, he preferred to subcontract to his friend William de Morgan. The success of Morris and Co. created a specific market for designs which were explicitly hand-made and appreciated for their unique qualities and workmanship. An emphasis began to be placed by individuals or small groups of craftsmen on ceramics exploiting variations of glaze and texture, originality of form and a deliberate sense of being avant garde.

The greatest value perhaps of the smaller, more experimental potteries that grew up was that they provided space for research and experiment with both the chemistry of ceramics and with its forms. In many cases this began as explorations into older techniques in order to revive them but turned into some very progressive research.

It is not as easy to separate 'Art Potteries' from commercial manufacturing as one might think. In many cases, artist-potters relied on a certain division of labour in their workshops, employing trained throwers etc., and indeed many in time became quite large businesses. At the same time, some of the larger factories, seeing that an additional impetus had been given to ornamental production, began making 'Art Wares'. Skilled throwers and decorators were available among their work forces and artists could be brought in from outside to enhance the artistic content.

In the 60s and 70s majolica was produced by Minton decorated with designs by the sculptor Alfred Stevens, and the painters were strengthened by the influx of emigrés after the Franco-Prussian War from factories such as Sèvres. These included Lessore, Louis Jahn etc. Specifically to mark a new relationship between the Minton factory and the art-world the Minton's Art Pottery Studio was opened in South Kensington in 1871 under the direction of William Coleman. This was designed to give employment to students from the Government Schools at South Kensington. The design reformers like Cole had also campaigned for the re-organizing of design education to

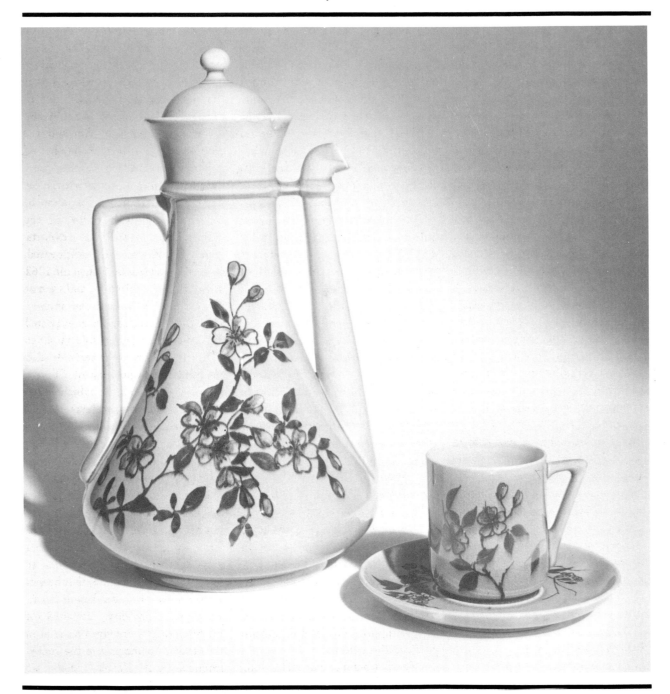

make it more appropriate to industry but there was still a tendency to concentrate on two-dimensional skills and there was still a firm belief in making Fine Art the top priority.

As a result the designing done at Minton's Art Studio consisted mainly of painting on biscuit-fired whiteware brought from Stoke. This was enhanced by the policy of also using the studio to teach ladies the art of china-painting. While such a policy in itself was no bad thing, it did tend to perpetuate the idea that Art in the form of pictorial imagery could be applied to manufactured articles. It made no contribution to the concept of design as being the forming of the whole object. The Studio, while it gained great critical acclaim, was not nearly as successful financially as the production of ornamental ware at the Stoke factory. After a fire in 1875 it was not rebuilt.

Perhaps the best known firm to take advantage of the growing demand for individualized pieces was that of Doulton. This firm was not concerned with supplementing uncertain tableware sales but was positively seeking expansion, using the profits from the growing demand for stoneware sanitary and building

Coffee pot, saucer and cup designed by Christopher Dresser in 1880 for the Linthorpe Pottery in Middlesborough.

supplies. The concern with hygiene and provision of piped water in London meant that what had been a relatively modest sized works early in the 19th century was, by 1867 under Henry Doulton, an extensive pottery.

Perhaps it was the financial success of the firm at that time which made him willing to take the risk of getting involved in what John Sparkes, the principal of Lambeth School of Art, called the *"higher sphere of Art Pottery"*. Sparkes persuaded Doulton to employ ex-Lambeth students and allow them to develop their own forms and techniques using the stoneware technology already available. The studio was successful and the number of artists employed increased steadily until the end of the century. In the 80s and 90s new bodies were added to the range and more experiments made with glazes and colours. Many of these experiments were to prove of great use to more general manufacture when, after the award of the Grand Prix at the Paris exhibition of 1878, Doulton decided to extend this interest in domestic pottery by acquiring the Nile Street pottery in the Potteries area itself. Like the Minton studio, but with much more success, Doulton included many women amongst his employees, who had the opportunity of a reasonably paid creative career.

The elaborate revival styles of the

50s and 60s no longer satisfied those who wished to be considered avant garde in their tastes. The new ideals of craftsmanship and a growing taste for simplicity among those who prided themselves on a knowledge of aesthetic values coincided with, and was reinforced by, a fresh availability of Japanese wares. These had been known in the 17th century but after that the virtual closure of Japan to Western trade had moved all the emphasis to Chinese exports. Japanese designs first reappeared, and made a major impact, at the 1862 International exhibition, and then at Paris in 1867. At first this interest took the form of collecting imported examples from Japan, sold in shops like that of Arthur Liberty. It also renewed the popularity of Chinese blue and white ceramics which, in the earlier 19th century, had mainly been superceded by the more colourful and overtly exotic late Ch'ing wares. The differences between the Japanese and Chinese forms was often confused and as soon as this demand was realized, European firms quickly began making a rather generalized 'oriental' style. These were either more expensive bone china like those produced by Worcester or the cheaper earthenware of Staffordshire. Forms which were obviously designed for western usage were given handles in the form of bamboo and the topographical and flower prints so

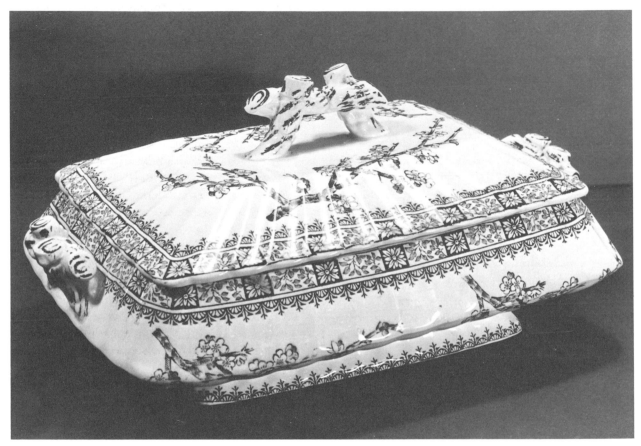

favoured in the middle of the century were replaced by an asymmetrically placed prunus-blossom type print.

In America as well, the great Centennial Exhibition in Philadelphia in 1876 contained, as a result of America's trade treaty with Japan, a large exhibit which began a widespread interest in Japanese art and influenced public taste as much as the work of contemporary designers.

The American public in the latter half of the 19th century were also becoming increasingly concerned with the quality and range of products available for the home. Here too advice about home-making was increasing; not only that of a practical nature, but advice on choices for furnishings etc. aimed at encouraging discrimination on the part of the housewife as mass-production offered a greater choice of goods.

Covered vegetable dish. The oblong fluted shape is decorated with a transfer of a thorn spray and has rustic handles loosely inspired by oriental motifs.

A blue and white transfer printed jug with inset pewter lid, decorated with oriental motifs and a modelled bamboo handle. Worcester Royal Porcelain Co. Ltd, 1895

Charles Eastlake's book *Hints on Household Taste*, a series of essays written over a number of years in England, was published in America in 1869. Eastlake had learnt from Ruskin and Morris. He condemned the diversity of borrowed styles and preached simplicity with a concentration on functional form. The Americans were very conscious that many of their designs were 'borrowed' from Europe or that their goods were produced in Europe, so the aim of simplicity and morality that they could see in their own rural forms, such as Shaker furniture, offered not only (as Eastlake intended) a relief from a multiplicity of historical styles but also the possibility of a national cultural identity.

This interest in the simpler functional forms was not however, shared by all Americans. As Europe redoubled its efforts to sell to the USA, despite import tariffs, the temptation to display decorated pottery as a status symbol was too great to resist. The *Pottery and Glassware Reporter* in 1879 noted that: *"There has for some time been springing up a demand for decorated ware. The splendid displays which were shown at the Philadelphia Exhibition gave a great impetus to this branch and has induced American potters to go into the manufacture of this class of goods."*

Only four years later it was evi-

dent that the general public did not yet have confidence in their own industry's ability to compete with the caché of imported goods. The same journal in 1881 reported:

"The lamentable lack of native talent, and the consequent lack of artistic ceramic decoration is, and will be for some years yet – until popular art education becomes a reality instead of a dream with us – the chief obstacle to the general appreciation and use of American porcelains. It is true that all our domestic pottery and porcelain is already decorated here, and much of it decorated well (but chiefly by foreigners): It is true that much of the imported porcelain is also decorated here, being imported white, so that buyers who fondly imagine they are getting European decorated ware may really be getting home decoration (which happily does not seriously lessen its intrinsic value, whatever the buyer may be disposed to think of it) but it is also true that this simple style of decoration will never elevate our porcelain into artistic competition with the European, even at home, nor recommend it to those whose patronage it is most desirable to attain, those of cultivated tastes and ample means who desire and are willing to pay for artistic decoration."

The efforts made by the American potters at the exhibition were noted with some alarm in England, though. The *Pottery and Glass Trades Journal* recorded that the late exhibition at Philadelphia enlightened the world in respect of American pottery; considering the comparative youth of the industry the results were very good.

Events were taking place, however, during the period of these reports which were to have an effect on the public's view of American ceramics and which ultimately contributed to the development of education in ceramics.

A combination of the desire for individualized ware and an opportunity for women to pursue an artistic career prompted both Mary Louise McLoughlin and Maria L. Nichols to take up china painting in Cincinnati. Nichols opened a pottery and began to bring in other workers, many of them women, in 1880. This, the Rookwood Pottery, was very successful and won a gold medal at the Exposition Universelle in Paris in 1889. Their successes encouraged interest in American art pottery and other similar ventures were started. Demand for porcelain painting grew and information began to be circulated concerning techniques, available materials and suggestions for suitable designs. Adelaide Alsop Robineau became a porcelain painter and from 1899 edited with her husband the *Keramik Studio* which disseminated ideas and information about art ceramics.

Magazines like the *Ladies Home Journal* also ran articles on china painting, suggesting it as a means whereby a woman could carry on an independent living. There was also a demand from amateurs who wished to be able to decorate their homes with their own artistic objects.

The types of designs suggested in the *Keramik Studio* by Robineau are of interest because they map the shift in approach to design taking place in the last years of the 19th century and the first of the 20th.

In the earlier editions, naturalistic flower or animal painting is suggested as most appropriate for purely ornamental pieces while a more stylized treatment of historical or exotic ornament is recommended for functional tableware. The development of the more sinuous, flowing sytlization of natural forms, however, which was known as Art Nouveau or Jugendstil in Europe soon becomes evident in the designs.

Art Nouveau is generally typified by its use of natural forms in an effort to break away from the historical eclecticism of the earlier 19th century. The ideas of pattern making and linking of pattern and form held by Morris and later members of the arts and Crafts movement combined with new thinking about the nature of painting by members of the fine art avant garde.

The Paris 1900 Exhibition was where much of the new work was seen and aroused great interest. In Britain initially it was deplored, as it appeared to contradict the idea of 'truth to materials' which was so strong in the later Arts and Crafts movement. Its attempts to break with tradition and create new forms using new materials were too extreme. The surface patterns however, with their sinuous, flowing lines were gradually adopted, though in many cases in a purely superficial way.

Factories in Europe who had brought in outside artists in their attempts to re-establish themselves were producing pieces in this new style. Meissen produced designs by Henri van de Velde, Olbrich and Niemeyer but the factory management were fairly disparaging about the results. The arrival of Theodor Schmuz-Baudiss at Berlin in 1902 marked a change in policy at that factory. His introduction of new designs and the use of outside designers made possible the work produced in later years by advocates of the Modern Movement.

At Sèvres, under Theordore Deck, artists and sometimes architects like Guimard produced plastic forms using the softer-paste porcelain body. It was the potential market in America which had caused Philipp Rosenthal to found his porcelain painting firm in 1879. Having emi-

Ceramic plate designed by Peter Berhens and made by Bauscher Weiden, c.1901.

grated to America he realized the potential and returned to Selb where he bought in white ware and decorated it with the help of one other painter. The entire output was shipped back to the United States. By the early 20th century he was making his own shapes and decorating them with a simple and restrained version of the New Art.

The *Keramik Studio* was in touch with Europe and Robineau persuaded Taxile Doat to allow them to publish a translation of his treatise on high-fired porcelain. The concern of some Europeans like Doat was shifting from an initial interest in the later decorated Japanese wares (whose asymmetry had contributed to the formation of Art Nouveau), to

Secessionist ware plates by Leon V. Solon and John W. Wadsworth. Slip-trailed and moulded decorative ware based loosely on the Viennese works were produced by Minton's between 1902 and 1914.

attempts to use the techniques of much earlier Japanese forms. It signified a shifting of focus from surface decoration to the forming of the shapes and their textures.

Adelaide Robineau herself became dissatisfied with painting on existing whiteware and began developing her own forms in porcelain and experimenting with glazes. These experiments with techniques provided valuable research some of which was to be of use to general manufacture, but it also signalled a divergence of thinking which led to increasing polarization between so-called studio and commercial ceramics.

To many factories the interest in the Japanese or the New Art were just new categories of pattern which could be applied to existing shapes. They took their place alongside the sprays of roses or neo-classical border motifs all of which enjoyed a demand from a certain section of the market. The larger the number of variants, the larger the market.

In the 1880s, in Britain alone, there were over 500 firms producing tableware, all competing both at home and overseas.

ART AND INDUSTRY

WHEN the *Pottery and Glassware Reporter* had referred to art education as being a 'dream' in 1881, the writer was mainly thinking of educating the public rather than the designer. But after the turn of the 20th century the lack of either scientific or aesthetic training was becoming increasingly evident. The proliferation of patterns and the operation of processes on the basis of empirical knowledge handed down over the years was being challenged by the need to compete more efficiently. The critics who had begun their campaigns about the standards of design turned their attention again to the question of education. The effects of the First World War were to reinforce their arguments.

The main criticism in Britain against the schools at South Kensington was that they were still too concerned with training students to produce drawings for designs while they had very few facilities for ever testing them out. One of the problems was that the grants available for training were awarded centrally by the London Schools for courses which were based on the concept that the teaching of design should be concerned with general principles. These ideas had been proposed in the 19th century as the best way to teach students and as a means of getting away from a situation where training was at a low level and specifically for one industry. However, there was still a tendency to emphasize the importance of the fine arts, and the grants system prevented students from being allowed to specialize in the practice of one type of design. The same type of thinking influenced the sciences and, while students could enter the South Kensington system for an examination in pure chemistry, no teacher could be found to teach them applied chemistry, simply because in that subject they could not earn grants. Students who did go to the Schools in London from the Potteries often did not return to work in the industry because they were encouraged to go into teaching or other types of employment instead.

Awareness of this situation led to calls for a School or Institute to be established which would teach together the science, art and technology of ceramics. These demands started at the turn of the century and continued for the next 20 years.

In an article in the *Pottery Gazette* in February 1900 both Germany and the United States were quoted as precedents for this kind of education. The two existing schools in America were the Ceramic School at Columbus, Ohio and that of Trenton, New Jersey. The Columbus School was part of the Ohio State University and was fully equipped for scientific clay working and although it had no art department as such, drawing — both mechanical and freehand — was taught as part of the course. The Trenton School in the other main pottery producing centre was paid for by a combination of city and state funding, together with fees and subscriptions, and was mainly an evening school designed to train people already working in the industry. It was claimed to be the only school in an English-speaking country where

the science, art and technology of pottery were all taught under one roof.

This school had come about due to a need for expertise felt in America, and it was largely the result of the energies of the principal Charles F. Binns working with local manufacturers and civic authorities. Charles F. Binns was in fact born in England at Worcester. He was the son of Richard W. Binns, a director of the Worcester Royal Porcelain works, where he was apprenticed at the age of 14. He left to study chemistry in Birmingham but returned to Worcester to set up a ceramics laboratory for research and to try to bring the production of the factory under more scientific control. He went to the United States in 1897 to become principal of the technical school in Trenton where he put into practice his ideas about education in ceramics.

In June of 1900, America was again being held up as an example to English education. This time it was with regard to the founding of a new school in the State of New York at Alfred University. It was to have extensive new buildings with chemical and physical laboratories as well as studios, a library and a museum. The kilns were to be fired by natural gas, the use of which was to form part of the research. As director, the trustees appointed Charles F. Binns from Trenton. The new School was described not just with envy for its facilities but with an awareness that it might well improve the success of the American industry.

Before the First World War, German design meant to the pottery industry cheap imports of fancy goods decorated with crude, bright colours and liquid gilding, or alternatively the supplies of lithographic transfers, or decalcomania, as they were called in America. These were introduced into Britain in the 1880s, the technique of printing having been developed there using English-invented transfer paper. Originally most of the designs were German, notably rather heavy classical or rococo border prints.

By the beginning of the 20th century specialist firms had grown up in the potteries to produce 'English' designs, though there is evidence that they still relied heavily on German technology and skill. Some firms still printed the transfers in Germany. J.H. Bulcher & Co. of Hanley was reported to have acquired 'an additional factory at Nuremburg' to produce on-glaze lithos. It was partly this dependence on Germany which caused a crisis during and after the First World War.

The so-called 'English' designs were a modification to lighter Adam-style neo-classical motifs which were becoming popular particularly for tea ware. Like the engraved plates used for under-glaze transfers throughout the 19th century, many were derived from printed sources not intended for ceramic decoration and were parts of pictures rather arbitrarily placed on the forms. Lithographic transfers were seen by the critics as one of the major sources of decline in the standards of ceramic decoration with which Germany was associated.

The reason why German goods were cheap was because the smaller German firms were suffering from lack of trade around 1908-10 and cutting prices drastically in order to sell. This 'dumping' was made easier by the fact that their labour costs were considerably lower than in Britain and America. In Germany women workers were used to a much greater extent than in England, even for the heavier manual jobs. Even so, the hardship in the industry caused by low prices was considerable.

These images of German design were very different from the work of the Secessionists in Berlin or that being promoted by organizations such as the Deutsche Werkbund. This organization, founded in 1907, was intended to reconcile art and industry. It was to bring together designers, journalists, industrialists and teachers in an attempt to formulate a new approach to the problems of design in industry. However, even within this body, conflicts arose about the value to be placed on hand-craftsmanship as opposed to that of

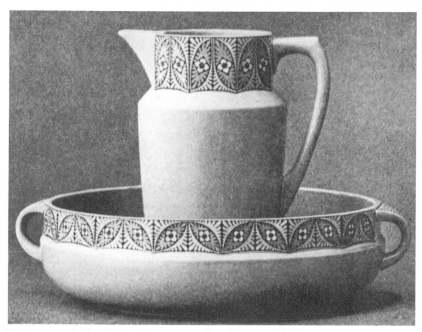

Toilet ware designed by Chr. Neureuther for Waechlerbacher Steingutfabrik. Illustrated in The Studio Yearbook, *1911.*

machines. Handwork, for some, still had the connotations of integrity with which the Arts and Crafts movement had imbued it, while for others the real need was to create design solutions to the problems of mass-production which would involve a new 'machine aesthetic' for the 20th century.

Van de Velde, the Belgian designer who had worked in Germany since 1900, supported the former view while Hermann Muthesius, who trained as an architect, believed that some degree of standardization, and hence the development of standard forms, was necessary to commercial industrial production. But the artists gained more support and the organization's influence on industry was limited to those few firms who had originally supported its ideals. Nevertheless, it was through the Werkbund's exhibition in Cologne in 1914 that a number of British designers were made aware of its work, as well as through its publication of recommended designs for household goods which included tea- and coffee-ware etc. Some of these designers formed the nucleus of the Design and Industries Association, including in its membership both Harold Stabler and Harry Trethowan.

The British Board of Trade in 1914 organized an exhibition to warn the public and manufacturers of the threat posed by cheap goods produced by the 'enemy', and it included examples of 'dumped' German ceramics. The Design and Industries Association (D.I.A.) members, perhaps misunderstanding the propagandist nature of the exercise, felt that German design such as that of Werkbund members was not represented, and they set up an alternative collection using the occasion to publicize their own similar intentions to improve standards of design and to bring industry and artist together.

Harry Trethowan, particularly, was to become one of the main protagonists in the debates on standards of ceramic design, both through his professional role as buyer for Heal's china and glass department and as spokesman on ceramics for the D.I.A.

Harold Stabler, though originally a silversmith, was to become with Charles Carter and John Adams, a partner in Carter, Stabler and Adams – or Poole Pottery as it was more commonly known. There, he was able to put his ideas on design into practice.

During the First World War the output of many factories was curtailed and the export markets were cut off. Technical and electrical ceramic goods, many of which had

come from Germany before the War, had to be developed and the trade in domestic ware was very poor. Throughout the wartime period prices for fuels and raw materials inflated rapidly. Wholesale prices in May 1920 were 225 per cent above their pre-war level. Also there was an optimistic assumption that as soon as the War was over there would be a great demand for goods. Large export orders were booked which in many cases the manufacturers could not undertake or the customers pay for. Goodwill was lost on the part of both the producer and the importer. The expected boom in 1918-19 was not as high as hoped. To a certain extent the shortages during the War led the public to take what it could get, which meant that manufacturers did little to produce new competitive designs. This was soon over, however, and it became apparent that changes were needed. The call for better education in the ceramics industry was renewed with even greater force and additional bodies were set up to see what could be done.

At a meeting in January 1918 the Ceramic Society, which had been founded in 1900 to encourage the exhange of information on scientific research in ceramics, decided to start a separate Art Section which would be concerned with the decorative side of pottery for commercial purposes. Stanley Thorogood, the director of Art Instruction under the Stoke-on-Trent Education Committee, was elected Acting Secretary. It was hoped that this section would draw together designers, artists, decorative managers and all others interested in the art side of pottery.

One of the underlying reasons for this concern with pottery design was a renewed fear of possible foreign competition, particularly German or Austrian. What appeared to be lacking was an English style of ceramic design – the need for a national identity was acute. A correspondent in the *Pottery Gazette* in April 1918 saw such a style as solving all the industry's problems:

"This is why so many of the so-called art wares fail. They are not indigenous. They are laboured imitations or adaptations of styles of other lands, and because of that they are doomed to weakness and failure. This too, is probably the root of the unceasing desire for novelty. Had we a national style of decoration, either in form or in colour, we should ring changes on that, but we should ever keep within the limits of our own style – This lack of national characteristic beautiful pottery is the more remarkable as we have such a strongly marked national and beautiful 'house' style. Our half-timbered house of the 15th and 16th centuries will yield the palm to no national house architecture in the world."

Looking back like this to the architectural style of the 16th century was to be a feature in the development of suburban architecture during the 20s, as a basis for both the new council housing and speculative building. It was not an attitude which was to give much credence to the pressure of *The Studio* magazine or the D.I.A. to follow German or Austrian precedents.

In November 1918 an announcement was made that the Board of Trade intended to set up the British Institute of Industrial Art. This had been planned before the war but not put into operation until after it. It would organize exhibitions, including a permanent one of contemporary designs, and try to sell the work of designers and craft producers whose work was considered good enough. A government grant was to be made available. This was immediately seen by the manufacturers as government interference in free trade and an attempt to dictate taste to the makers and public alike. The idea of being rebuffed by being refused a place in the exhibition on the grounds that their work was not 'good art' did not appeal.

The same problems beset the first attempt by the Art Section of the Ceramics Society when they attempted a more local exhibition in January 1919. The aim was expressed more gently. It was to be 'an exploration'

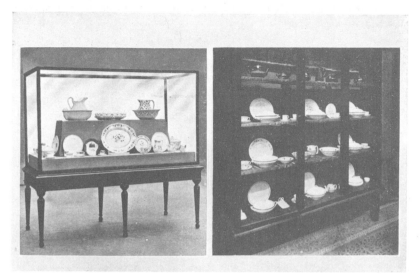

October 1, 1923. THE POTTERY GAZETTE AND GLASS TRADE REVIEW. 1649

Some of the exhibits shown in the British Institute of Industrial Art Exhibition in 1923.

into where modern pottery stood in relation to art. Rather than select pieces, all those submitted would be put to a panel of experts for comment, in this case Professor Anning Bell and W.B. Dalton. Few of the manufacturers participated as they were sceptical as to the use of it.

The judgement of the panel was that the technical side of the ware was excellent but the designs were still too derivative and Anning Bell re-iterated the need for an English style. A second exhibition a year later was more successful. What was seen as the very high-handed exclusivity of the adjudicators was in this case modi-fied somewhat at the insistence of Gordon Forsyth. Forsyth was a very competent designer of ceramics who produced work for A.E. Gray and Pilkington's among others and who had just been appointed to take over from Thorogood as Art Director for the Education committee, a position from which he was to campaign continually for better education in ceramics. Forsyth wanted the panel to include in their comments pieces particularly for the cheaper end of the market which, though they did not gain the full approval of the professor's educated, middle-class views, did in Forsyth's opinion provide reasonable solutions to design at the level of market for which they were intended.

It was this perceived condescension on the part of the critics and their apparent incomprehension that there were different needs within sections of the market which remained a stumbling-block to useful communication with the industry. It remained very much their view that both manufacturer and public were in need of 'educating'.

In the adjudication of the pieces exhibited, criticism was again expressed concerning the standard of lithographic transfers, and Anning Bell's fine art background perhaps made his suggested solution predictable. Hand-painting according to him, was the answer. Although this suggestion was made from an ideological standpoint, it did offer a temporary practical solution.

The reliance on the ornate surfaces which could be provided by lithographs and the ultra-refinement of materials between 1914 and 1920 was partly due to the scarcity of expert model-makers, who in many of the smaller firms contributed a major part of the design activity. In 1920, *The Pottery Gazette* reckoned that in the whole country there were not more than 50 fully trained model-makers and that in the North Staffs Potteries only some half dozen were apprenticed to serve 300 factories.

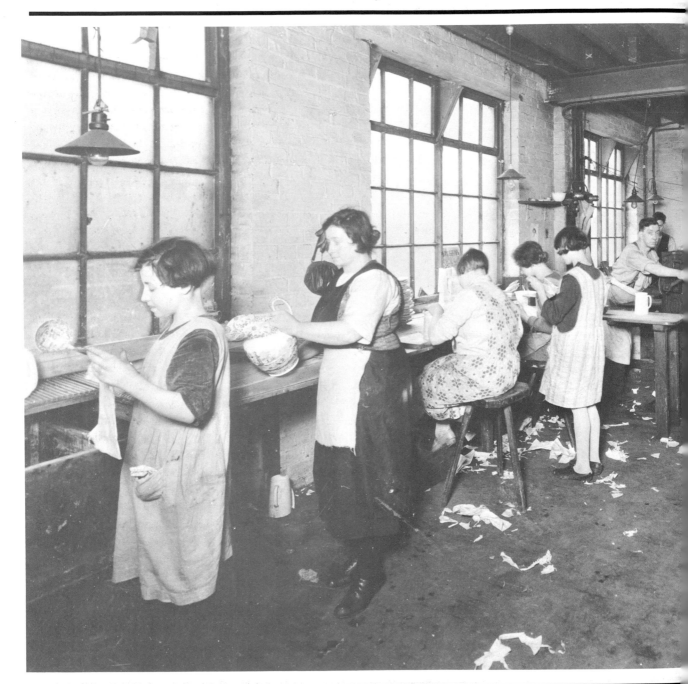

Quite a number had emigrated to find better pay and conditions.

The apprenticeship system had begun to decline in the late 19th century and it had almost disappeared by the second decade of the 20th. For most of the 19th century manufacturers had virtually sub-contracted work to their skilled craftsmen, who paid their assistants from their own wages and were responsible for training apprentices in the skilled trades. The traditional skilled work, however, began to lose its wage value against more mechanical operations. It ceased to be viable to pay assistants out of these wages, and the incentives to train for five to seven years to become a journeyman were not there when more could be earned after shorter training in the newer methods. The operator of an aerograph or spray-gun for decorating was sometimes paid more than a skilled draughtsman. The National Society of Pottery Engravers had had to take industrial action just after the War to try to get improved wages and conditions and even then were getting less than two shillings per hour.

The dearth of skilled model-makers and decorators encouraged the

Part of the decorating shop at Copeland's in the 1920s showing the printing and application of transfers by young girls.

use of cheap lithography on existing shapes, often very crudely and insensitively applied. When this crisis was acknowledged, and the lack of apprenticeships realized, the manufacturers themselves began to look to the local Art Schools to supply the craftsmen and women needed. This finally engaged them too in the educational debate.

The Borough of Stoke-on-Trent had five Art Schools mainly supplying education for craft-workers, either full-time for the younger students or evening classes for those already employed. A few who showed talent and could gain scholarships went on to continue their training at South Kensington. When Gordon Forsyth was appointed, his job was to co-ordinate the work of the five schools some of which were using old buildings and inadequate equipment. Due to the potters' current concern with the art education of the area he was also asked to be Art Adviser to the British Pottery Manufacturers Federation. This was a new position and gave him an unprecedented opportunity to speak out for education in the area. What was needed was provision for design education equivalent to the scientific education on offer at the Technical College in Stoke. One of the art Colleges had to be given the leading position in the Stoke educational system and fully equipped to practise the entire range of skills needed in the

Cheap plates of the late 1920s showing enamel painting over lithographic transfers and simple on-glaze hand-painting, c. 1927.

industry. It should also act as a focus for improving standards of design. In the meantime the lack of adequate making facilities in colleges exacerbated the tendency to think of design as being concerned only with surface pattern.

In 1921 a preliminary report was published by the Industrial Art Committee of the Federation of British Industry suggesting ways for greater co-operation between industry and the Art Schools, especially the Royal College (South Kensington). They had approached Professor Rothenstein, the principal, for suggestions. Among several other ideas, he suggested the funding of a lectureship at The Royal College in industrial design as applied to manufactures. This the Committee rejected, believing it to be impossible for one person to have knowledge of the conditions of the many different industries involved. Visiting experts, they believed, would be better.

Even at this stage the emphasis in Britain was that designers had to be people with an intimate knowledge and experience of each industry in itself, and with its materials and practices. As it was, a ceramics department was established at the Royal College of Art later in the 20s, but it was under the guidance of William Staite Murray, whose interest was specifically in promoting the concept of ceramics as an equivalent form to the fine art of sculpture. He was in no way concerned with industrial production. It was not until the re-organization after the Second World War putting Professor R. Baker in charge that concern with design for industry came at last to the fore.

Representative Examples of New English Pottery
on Show at the British Industries Fair

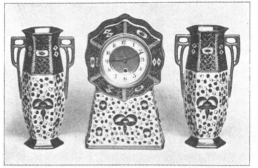

STAND No. G1.

STAND No. G1.

Above: Clock case and vase by Messrs. Lingard, Webster and Co., Tunstall, in imitation of Austrian designs.

Below: Hand-painted soup plate using wash-bands and on-glaze decoration made by Minton's.

As many of the lobbyists for art education in the Potteries were influenced by the ethics of the Arts and Crafts movement, they, like Anning Bell, tended to romanticize the value of hand-craftsmanship. A tension therefore seemed inevitable between the needs of manufacturing industry and the type of training likely to be favoured by the teachers. However, the cessation in imports of German lithographs coupled with the low wages that could be paid to the decorators, mostly young girls, meant that in this instance industrialists were prepared to consider the advantages of hand-painting. If effects could be produced relatively cheaply which supplied a growing demand, especially among the educated middle-classes for an English pre-indust-

rial look, then this made commercial sense. Because it was a buyer's market for labour, craft values could be supplied more cheaply than aerographed or printed designs.

Two advocates of hand-painting who had some influence in the early 20s were A.E. Gray and Harry Trethowan. Their influence on design in the industry came from their experience outside it as retail salesmen – the former with H.G. Stevenson Ltd of Manchester, and the latter with Heal and Son Ltd of London.

A.E. Gray started as a junior salesman with H. E. Stevensons in 1887 where he became particularly involved in the china department. In 1907 he took over a wholesale warehouse in Stoke in order to supply pottery throughout north England. From this, he moved to setting up his own decorating house in Hanley using white wares brought in from other firms. Gray was a firm believer in Ruskin's views and argued that mechanization, particularly of decorating processes, had taken away the satisfaction of creative achievement from workers in the industry.

In the early 20s the emphasis of his work was all hand-decoration, on-glaze painting and the revival of lustre-painting. He produced some patterns for a 'Tudor' tea-room in Leeds which came to the notice of Waring and Gillow Ltd who then ordered lines from him and so

increased the scope of the business. The lustre-painted designs complemented the revived 'Jacobethan' furniture which was a feature of their showrooms at the time. A number of painters and designers started their careers with him where the training in hand-painted techniques and the care with which they were executed provided a firm base for their later work. Susie Cooper was one who began her career in this way.

Ambrose Heal had developed his business to cater for a reasonably wealthy section of society who appreciated finely made furniture within the Arts and Crafts tradition. He extended the scope of his business to combat the decline in trade due to the war and in 1915 appointed Harry Trethowan as buyer for the China and Glass department. Trethowan was a firm believer in the D.I.A. formula of 'fitness for purpose', simplicity of form and economy of decoration. In 1917 the D.I.A. had a small section in the Arts and Crafts Exhibition Society's show at the Royal Academy bringing together a number of designs which they felt conformed to these ideals and which would stand comparison with the German Werkbund. Among them were some bright, sponged and brushwork patterns produced by George Jones & Sons for export to West Africa. These products were the cheapest produced by the company and were of inferior quality

for off-loading to the Third World, so it was naturally a source of some incredulity when Trethowan showed interest in them. He managed, however, to persuade the company to produce designs for Heal's on better quality ware using similar techniques, and an effective business was soon built up. George Jones & Sons continued to supply earthenware with underglaze paintings during the 20s and 30s and at one time had at least 40 paintresses employed full-time producing designs such as 'Country Bunch', 'Blue Leaf', 'Hedgerow' etc.,

all of which appeared in the Heal's catalogues throughout the period.

While the patrons of Heal's had money to spend on tableware supplied by George Jones & Sons Ltd and Wedgwood, many households were reduced to subsistence spending. Even among the growing class of suburban white-collar workers, new consumer products and hire-purchase instalment payments took priority over the purchase of ceramics. In 1921 *The Pottery Gazette* reported rather gloomily, *"It would be difficult to recall a time*

The China and Glass department at Heal & Sons Ltd under Harry Tethowan as illustrated in Pottery Gazette *in August 1919. The technique of displaying the pieces spread out on Heal's furniture was new at the time.*

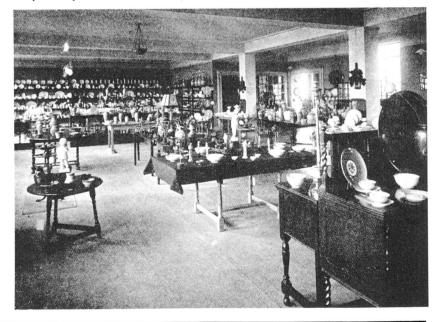

within the memory of the present generation when the output of the Staffordshire Potteries fell to quite so low an ebb and maintained it for so long a period."

In order to compensate for falling sales in useful tableware some of the smaller firms changed their produc-

'Urbino' ware by Burgess and Leigh Ltd – hand-painted and lustred ornamental ware illustrated in Pottery Gazette *in 1920.*

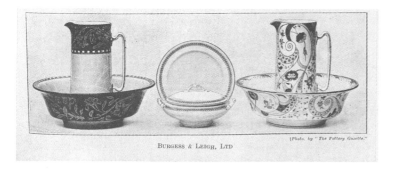

tion to ornamental pieces. The 1920s saw a resurgence of interest in 'art ware' using cheap hand-painting. The Canning Pottery Co. for example, which had previously concentrated on red earthenware and Rockingham teapots, launched a line called 'Decoro' Artware making use of the

red body and rich dark brown glazes while also adapting the use of coloured slips from the bands on the teapots to free-hand ornament. The ware sold quite well and tided them over a difficult period.

In areas outside Staffordshire too, the making of hand-painted ornamental ware was developing as a supplement to more utilitarian products. The firm of Carter, Stabler and Adams, which Harold Stabler had joined, was a subsidiary of Carter's making architectural ceramics at Poole in Dorset. Their designs were also based on hand processes, either on-glaze painting or the making of sculptural pieces. The new subsidiary was started in 1921 and, partly through Stabler's and Adams's contacts with the D.I.A., Harry Trethowan began to display their individual pieces as complements to the Heal's furniture. Many of the painted designs were the work of Truda Adams and were floral motifs based on Jacobean and peasant embroidery patterns. Elaborately stylized and brightly coloured they fitted very well into the new concept of an English style based on pre-18th century domestic design.

This greater emphasis in Britain on decoration to supply a wide variety of choice was in direct contrast to moves being made elsewhere to improve production and prices by rationalization.

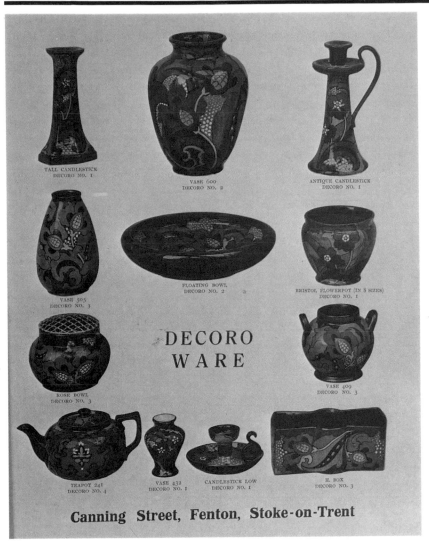

TALL CANDLESTICK
DECORO NO. 1

VASE 600
DECORO NO. 2

ANTIQUE CANDLESTICK
DECORO NO. 1

VASE 505
DECORO NO. 3

FLOATING BOWL,
DECORO NO. 2

BRISTOL FLOWERPOT (IN 8 SIZES)
DECORO NO. 1

DECORO WARE

ROSE BOWL
DECORO NO. 3

VASE 409
DECORO NO. 3

TEAPOT 241
DECORO NO. 4

VASE 432
DECORO NO. 1

CANDLESTICK LOW
DECORO NO. 1

H. BOX
DECORO NO. 3

Canning Street, Fenton, Stoke-on-Trent

'Decoro' ware made by the Canning Pottery Co. using techniques based on those they had developed for teapot manufacture. Advertisement in Pottery and Glass Record, *1923.*

In Germany and America – and also in Russia – measures were being introduced by legislation to limit the numbers of different shapes and types of ware being made. The evolution of standards and 'standardization' had come in response to needs within the mechanical engineering industries, where the advantages of interchangeable parts and consistency in manufacture were clearly recognized. Rationalization of sizes and specifications was undertaken by the German Standards Commission (D.N.A.) set up in response to military requirements in 1916, and the American Standards Association founded in 1918. Standards based on the best working practices in each case were intended not only to make components compatible, but by limiting the range, to encourage mass-production with larger runs at cheaper cost.

In July 1923, a report was published announcing the result of consultations in Washington between the Vitrified China Manufacturers Association, the American Hotel Association, officials of the Department of Commerce and representatives of the Chamber of Commerce of the USA. Their conclusion was that, of 700 types and sizes of hotel chinaware then in use, 540 were redundant and could be eliminated. All needs could easily be met by the remaining 160. It was reported that, *"One manufacturer has carried a line of 425 varieties whereas 76 per cent of business has been on a line of 42 items. The savings could be enormous."*

Action was possible as a major proportion of the American crockery output was for hotel and transport catering or for Government contracts. The reduction of lines meant

concentration on fewer shapes, less alteration of machinery and increasing use of mechanized processes.

In January 1924 Russia also introduced standard measurements for glass and porcelain goods in an attempt to step up output and mechanize an industry which until then had been very labour intensive.

These proposals could hardly have been more at odds with the view that, rather than concentrating on mass-production, the industry needed to become increasingly conscious of its artistic nature.

The terminology used in the debates on 'Art and Industry' at the time was important. The word 'Art' was interpreted as meaning firstly 'expression of self' and secondly 'expression of beauty' – emphasizing individualism (as opposed to collective effort) and the possibility of some universally accepted standard of what was beautiful. The former was difficult to make compatible with design for mass-production, while the latter was a major source of cross-purpose arguments between the critics and the makers. The ideal of self expression meant that the designs most often selected for exhibitions were 'Art wares'. These were often made using hand techniques, particularly decoration, which allowed a degree – albeit in many cases very small – of 'self expression'. It was difficult to see how this concept of Art could be brought into a successful relationship with the production of functional ware on a larger scale.

The belief that there was an accepted standard of beauty which industry, designer, critic and public could all appreciate or be educated to appreciate was also a problem. The industrialists, although they undertook very little organized market research, were aware that in fact quite different perceptions of beauty existed among the various sections of the market for which they catered. The critics on the other hand, usually spoke from a particular point of view based on their educated background and their historical knowledge about conventions of good taste. They assumed that their standard of discrimination was the correct one and the one to which all others should aspire. The notion that industrial products should be judged by purely

Group of two vases and a dish designed by Truda Carter for Carter, Stabler and Adams. The dish and right-hand vase were produced between 1925-1930, the vase on the left is slightly earlier c.1921-1925.

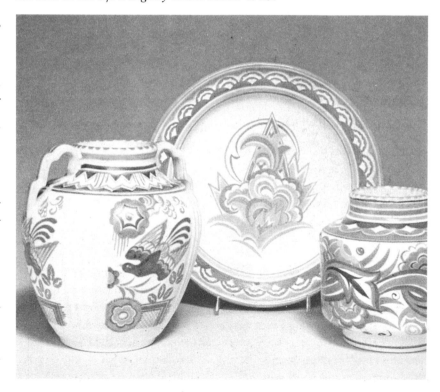

aesthetic standards beset much of British design criticism throughout the period.

In America too, although the strength of its industry lay in its use of modern manufacturing methods, and although it was taking steps to find the optimum range of products, some critics interpreted the idea of good design in aesthetic terms similar to those current in Britain.

After 1918 the Bureau of Education issued a pamphlet stressing that if the USA was to compete with foreign imports it must turn from its quantity methods of production and, through industrial art training, put the country's commerce on a quality basis. It stated: *"There are not three standards of good taste, one for the producer, one for the storekeeper, and a third for the person who buys the goods. Yet these three groups have in modern times each misjudged the others, because education has yet to standardize and inter-relate their interests and tastes."*

Charles F. Binns, then at Alfred College, wrote in a paper called *The Art of Manufacture and the Manufacture of Art* in 1923: *"As the matter now stands, we are manufacturing enormous quantities of general ware which is for the most part decorated as open stock patterns... but it does not make for the excellence which resides in individuality. It affords but little opportunity for the expression of personality in design."*

To achieve quality status Americans had to set aside mass-production for more individual work. Binns's view of art was similar to that of British critics: *"Art is essentially individual. If it means anything at all it means the expression of an idea, but mass-production tends to destroy this."*

In America, as in England, education was seen to be the answer to the problems of industrial art. The need for such education had been put forward by the Bureau of Education as early as 1900 but little had been done. The War brought home the degree to which industry relied on foreign design. When the import of decals or lithos from Europe ceased, it showed up the need for home-produced ones. Despite war conditions, a number of activities and suggestions were put forward but most of the projects were short-lived. After 1917 the opportunity was taken to try some more lasting solutions, as it became obvious that relations with Europe would never be the same as before. The previous flurry of articles and discussions had served to raise public interest in the question of design in the art industries. In 1917 the Smith Hughes bill became law, granting certain appropriations to establish vocational schools. The American Federation of Arts devoted part of its ninth conference at Detroit to industrial art and

Pottery designs by Edith Brown, made by the Paul Revere Pottery and illustrated in 1915. The American Art Pottery movement opened opportunities for women to become involved in ceramic design.

continued to include it as an item throughout the 20s. It also set up circulating exhibitions under the slogan 'Art in Every Home'.

The American Association of Museums also felt impelled to become involved. The Victoria and Albert Museum in London had originally been set up for the purpose of showing examples of both past and contemporary decorative art for the use of manufacturers and art workers, though by the beginning of the 20th century its role was being construed rather differently. The Metropolitan Museum in New York also had a charter stating that it was 'for the purpose of encouraging and

developing...the application of arts to manufactures and practical life'. At its 12th annual meeting in 1917 the American Association of Museums discussed the question of collaboration with manufacture. As a result, four museums developed divisions especially for industrial liaison.

The Newark Museum, New Jersey, was closest to the ceramic trades, while the Metropolitan held exhibitions of work derived from study of the collections in the museum. These contained examples of pottery and this basis for the exhibitions remained until 1924. It actively encouraged a notion of design based on historical sources. Newark Museum held exhibitions for the clay industries, where industrial work could be seen, though one of its important contributions was the organization of two exhibitions – one just before and one after the war – of German design, including work by the Deutsche Werkbund.

The Smithsonian Institution developed a department of industrial arts which put an emphasis on techniques and processes. In Chicago the Association of Arts and Industries had been active for some time and they persuaded the General Education Board to allocate funds in 1924 for a School of Industrial Art, while between 1917 and 1923 the Art Institute of Chicago operated 'The Better Homes Institute'. Apart from Newark, many of these museums dealt with a spectrum of industrial art and the emphasis, especially in the Metropolitan's exhibitions, was increasingly on room settings showing combinations of furniture, textiles, tableware etc. The aim was not so much to extol the uniqueness of the manufacturing processes (tending to be the case in Britain) as on showing the consumer how these things could fit into their homes.

Unlike the newer consumer goods industries in America, which doubled their output between 1919 and 1929, the pottery industry in the 1920s was marked by uncertainty and fluctuations. As in Britain this coincided with the calls for more artistic and individual productions.

The result was that in contrast with the hotel ware producers, those making earthenware began to increase the number and variation of shapes and patterns. The number of pieces included in the standard sets of tableware declined as the growth of American cities with their congested districts and high-rise blocks of apartments meant many households contained the fewest possible number of living rooms. Family size was also declining. The standard 100 piece set was reduced to 50. However, as novelty was in demand (because it was thought to represent a more artistic solution to design), many of the gains made in rationalizing products were not fully exploited until the 30s.

Until the 20s it had been common for some of the smaller American firms to concentrate on producing only one range of shapes and continuing it for several years. Now each ran more than one. While energies had gone into the organization of factories for the making of the ware, the same consideration had not been given to the mechanical development and general efficiency of the decorating departments, and until that happened decorating still depended heavily on the use of decals. Hand-painting was developed but the higher wage rates in America meant that too much labour-intensive decorating was uneconomic except for very high class ware.

To economize on the number of separate elements that had to be printed onto decal sheets, the 'three sprig' type was favoured – or its equivalent. This consisted of three sprays of flowers of graded sizes, large, middle and small, which could be applied in different combinations to the various pieces of ware. Dinner plates could have one large spray plus one small set at opposite sides, covering both the border and well of the plate; holloware such as cups could have the middle-sized spray outside plus the smallest inside the rim; side-plates might have the middle spray only, asymmetrically placed. Thus the design of only three elements could be

Advertisement for 'Pink Chateau' in the Heirloom range by Salem China Co., showing the use of traditional designs modelled on Spode. Illustrated in The Crockery & Glass Journal, *1926.*

Advertisement from the Crockery & Glass Journal, 1926, *for the Atlas-Globe China Co. introducing their 'Bona-Dea' shape.*

the need for replacement. These techniques were aimed at women of wealth, and appealed to their culture and discrimination.

One store buyer for china and glass reported:

"Women of culture and means buy a new dinner service perhaps as often as new jewellery. They learn to make a hobby of fine table service, and when a new pattern in Lenox, Minton, Haviland or other fine wares is shown, they immediately want to add it to their collections. Thus a woman purchasing a set for several or even one or two thousand dollars has by no means satisfied her chinaware need permanently... As to novelty service, women who entertain select new things perhaps several times a season, often buying an entire new luncheon service to work in with some novel or unusual scheme of decoration."

Colour was increasingly a selling point and as the emphasis moved to decoration even on cheaper ware, the hard white porcelain-like body was being superceded by a rich cream which gave a more effective background to the colour.

Even before the Paris Exposition of 1925, highly coloured glazes and geometric forms were being seen in continental exported ware. The developments of institutions such as the Bauhaus school in Germany with

used on a great variety of ware and the placing need not be so exact or time-consuming as the full border design, which had to be precisely fitted to each shape. The approach to the design of the spray or motif could be more or less stylized. It produced a form of asymmetry and running together of rim and plate-well which could later be seen on the modern coupe-shaped ware.

In America it was overtly recognized that the vast majority of purchasers of tableware were women, so the stores began consciously to market their tableware to them, emphasizing its fashion content and

their emphasis on design for machine production were not yet recognized whereas the designers and decorators of France were gaining wider publicity. With the apparent polarization of the consumer goods market between the wealthy wanting fashion and novelty and the lower-income families needing functional ware at the least cost, it was perhaps not remarkable that in an industry being urged to go for art rather than mass-production, they looked to the French for models.

What these designers were involved in was the opposite of type-forms for mass-production. Theirs were individual designs, made from

very expensive materials using all the time-consuming traditional techniques for wealthy and privileged patrons.

In 1922 Edward C. Moore Jnr., the son of the president of Tiffany's & Co., gave money for the Metropolitan Museum to purchase examples of the best modern decorative art from both Europe and America. The then curator, Joseph Breck, began to visit Europe and made buying trips in 1923, '24 and '25. The culmination was a visit to the Paris Exposition in 1925 where he purchased a number of the central exhibits, all of them French. Amongst others there was a piece by the French potter Lenoble and some work by Lalique.

The pieces, especially the furniture, caused a certain amount of controversy in New York where styles varied between revivals of early colonial designs and those influenced by the English Arts and Crafts movement. America, although invited, had not taken part in the Expo. on the grounds that the organizers had stressed that all the works shown should be original and 'modern in spirit'. Perhaps if they had been able to see in advance what the British manufacturers were planning to submit they would not have been so concerned, as much of the British ware was based on revived styles.

The General Education Board also granted funds to bring a selection of examples from Paris on tour. The exhibits were selected by Charles R. Richards, the Director of the Division of Industrial Arts, who was charged with this role by the Secretary of State for Commerce. He was also, with Frank G. Holmes and Henry Creange and the aid of 131 delegates from various industries, to compile a report on the exhibition in the light of its value to American industrial art and design. Their findings were published in a report issued by the Government in 1926.

Of the delegates, Mary S. Sheerer represented the ceramics industry. She had taught at the Sophie Newcomb Memorial School of Art in New Orleans and had been involved in running the Newcomb Pottery at the School. After the First World War as the interest in the Art Pottery movement declined, she gave up china-painting. From 1924 to 1927 she chaired the Art Division of the

'Autumn' by Frank G. Holmes designed in 1919 for Lenox China Co. Inc.

American Ceramics Society. But Frank G. Holmes and Henry Creange also had connections with the ceramics industry. Frank G. Holmes was the Art Director of Lenox China Inc. and designed many of their most famous lines between the wars, and Creange (though he was Art Director for Cheney Bros. the silk manufacturers), had acted as an advisor on design for the American market to the potters Johnson Bros. Ltd of Hanley. An article by him on 'Quantity production in the Art Industries' appeared in the *Crockery and Glass Journal* in December 1926. While the Metropolitan's collection and the travelling exhibition were seen mostly by the more museum-minded consumers, the reports of the delegation made their implications for ceramics known to the trade.

The French goods were generally expensive, whereas the geometric exuberance and colour usually associated with 'Art Deco' – as this style became known – were made available to a wider public by the imports of cheaper pottery from Czechoslovakia and Hungary. These countries were attempting to revive national styles in the form of peasant art, combined with influences from the British crafts movements and a knowledge of the work of organizations like the Wiener Werkstätten.

With the disintegration of the Austro-Hungarian Empire after the

Wash basin and water jug designed by Joseph Olbrich for Villeroy & Boch, Mettlach, c.1905.

War, Austria found that it had lost many of its more famous porcelain factories. These had been in the coal-producing regions which were now inside Czechoslovakia and the famous factory of Herend, established by Moritz Fischer in 1830, was ceded to Hungary. As the State Porcelain factory in Vienna had not survived the 1860s the need to revive industry in all these areas gave an impetus to ceramic design.

Although the State factory had closed, a number of decorating workshops had grown up in the late 19th century in Austria. These had been influenced by the secessionists Koloman Moser and Joseph Hoffman. One of the most significant was the Porzellan-Manufaktur, Joseph Böck. Böck founded the firm in 1898 when

he inherited a china shop. He worked with Koloman Moser and Joseph Hoffman as well as other pupils of theirs from the Kunstgewerbeschule. His was a decorating and distribution organization, and the pieces themselves were usually made on contract at other factories. This way of working allowed artists and designers to experiment with limited runs of ware

Coffee service designed by Theresa Trethan for the Wiener Porzellan-Manufaktur Joseph Bock c.1905

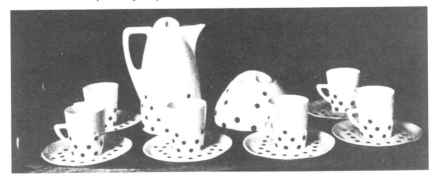

and individual ornamental pieces. After the War, Franz von Zulow started the firm of Augarten in Vienna which again many of the Wiener Werkstätten artists worked for. Their work combined rather exaggerated form with a very bright stylized use of colour, despite the calls for undecorated pure form made by some members of the movement.

In Czechoslovakia, Artel was founded in 1908 in imitation of the Wiener Werkstatten. Its members favoured strong geometric structures with hand-painted flat colouring. This avant garde studio production began to affect the numerous small porcelain factories which were being encouraged to increase exports after independence. Labour in these was cheap and coal prices were being lowered. America began to increase imports from these areas despite protective tariffs and these geometric forms, often with bright metallic or lustre glazes, began to appear on the shelves of the china department.

In Britain the articles and reviews of Viennese design cut little ice with manufacturers' suspicions of European design, which was felt to be alien to 'English taste'. Critics, too, were more interested in pursuing the idea of a national style. This attitude was summed up in a lecture by W. B. Dalton, Principal of Camberwell School of Art, to the Ceramic Society Art Section in 1919: *"The Futurist and Cubist movement invading pictorial art is a rebellion against accepted canons in art, and some features of Cubism have come to stay, for a time at least. Cubism is already beginning to influence the use of floral form. Its symptoms are angularity and primary colours, these will presumably invade the Potteries before very long, as cubist camouflage knows no chains or fetters."* But Anning Bell looking at the second exhibition of the Art Section could be more sanguine: *"There is very little foreign influence on the design generally, and that I think, is right enough. Each nation should try to work along its own characteristic lines."*

British manufacturers played a rather half-hearted part in Paris in 1925. Most of them had decided to work towards the British Empire exhibition at Wembley in 1924 instead. Their major export markets apart from America, were the Empire and in purely trade terms this seemed much more important than competing in Europe. Even this exhibition was plagued with difficulties. The potters nearly pulled out altogether when it was discovered that Jo Lyons, who were doing the catering, were negotiating with European firms for the tableware for the restaurants. This was because the state of the German mark meant that prices were extremely depressed. The appeals to patriotism that followed both in Parliament and elsewhere, averted the crisis but the incident gave rise ultimately to the 'Buy British Pottery' campaign and appeals for tariffs and anti-dumping regulations.

A glowing description of the Empire exhibition is given in the *Pottery Gazette* describing its function as follows: *"Its purpose is to promote Imperial interests, to create in the minds of all Britishers a clearer concept of the possibilities of the Empire and Empire trade, and, apart altogether from the entertainment which a visit to Wembley affords — there is still an educational function which the British Empire Exhibition cannot fail to exert upon all except those who have nothing more to learn."*

Within the exhibits what was apparent was the resurgence of interest in neo-classicism. Anning Bell in discussing sources of ceramic design, even though he was expressing the need for a national style, had suggested the late Italian Renaissance as most appropriate, the 16th century Italianate Jacobean period being seen as typical of vernacular building style at the time.

This renewed interest in classicism, evident in many of the buildings representing the home nation, was exploited to the full by firms such as Josiah Wedgwood & Sons. Their stand was designed by Oliver Hill. The entrance was a triumphal arch,

solid and massive in appearance, decorated with a series of plaques taken from original 18th century moulds. This was greeted enthusiastically by the press as, *"Wedgwood in feeling, for it portrays all the refinement of the Adam period... The architect is to be congratulated on having come so near to the spirit which was needed to lend that dignity and old-time respect to the Wedgwood exhibit to which it is entitled."*

It was far from the lightness of the original Adam, but it certainly represented solidity, permanence and authority. The exhibits within combined contemporary decorative wares with 18th century reproductions in creamware and jasper. The Doulton stand also prominently featured the 'Della Robbia' fountain in faience and another entrance in Italian Renaissance style featuring Della Robbia-type lunettes. The stand of William Moorcroft similarly displayed the classical origins of the Wembley style in the symmetry of its collonade and its curious weight of treatment. Both exhibits and presentation at Wembley, however, were far from the aims of the Paris Exhibition in the following year.

Even the *Pottery Gazette* admitted that the British ceramics at Paris made a poor showing but excused them by stating that the manufacturers obviously would not show new work as requested for fear of it being copied. Many of the pieces that were there were in fact revivals or had been available for some time. Some of the pieces made by George Jones & Sons for Harry Trethowan at Heal's won an award, but this was the only firm to do so besides Minton's and Worcester.

The interest shown in the Paris Exposition by the British on an official basis was markedly slight when compared with that of America. Most organizations like the D.I.A. dismissed it as too concerned with luxury and extravagance, but the rather tired British adherence to craft simplicity and individuality which they still advocated was answering neither the demands of the luxury market nor increasing machine production.

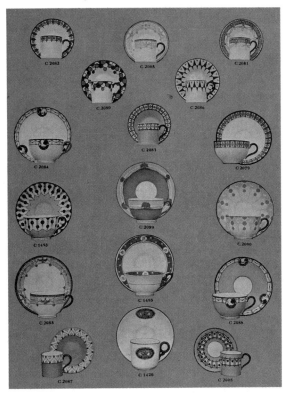

Tea and coffee services made by the Worcester Royal Porcelain Co. Ltd in 1922. Designs vary between the neo-classic 'Adam-style' borders and the brighter, more geometric patterns with solid, groundlayed colours. Advertisement in Pottery Gazette, *1922.*

THE PROBLEMS OF MODERNISM

WHILE the spirit of Wembley still dominated the official view of design in the later 1920s in Britain, the manufacturers themselves could see evidence of a new demand for hand painted and fashionable wares. Whereas in the previous decade their interest had centred on the need to increase the artistic content of pottery, now the question was raised as to what kind of artistic content it should be.

The miners' strike and subsequently the General Strike created great uncertainty in trade and any additional novelty which could be contrived was tried. It was this climate which allowed some designers to find support for ideas which perhaps in more prosperous times would have been dismissed.

One such designer whose work has come to epitomize this is Clarice Cliff. She gained her design training from a background in the trade. She was apprenticed to learn free-hand pottery painting at the age of 13 before moving on to study lithography design. At 17 she joined the firm of A.J. Wilkinson, officially to work on lithos, but in fact she became more involved in modelling, gilding and painting as in the period immediately after the First World War the firm began to concentrate more on decorative and art wares.

They had begun to produce these under Arthur Shorter who had purchased an interest in the firm when his brother-in-law A.J. Wilkinson died in 1891. Arthur Shorter had begun his career as a china painter. He spent two years at Minton's painting landscapes before setting up on his own. When he took over, Wilkinson's had only been making white granite ware for the American export trade, but the demand for this was declining as the Americans were developing their own production. With his experience in decorated ware, Shorter introduced new art ware lines, 'Oriflamme', 'Thibethan' and 'Rubiyat' which were based on Art Nouveau shapes and typified the interest in exoticism.

The demand for these shapes was

An advertising poster used by Derry & Toms on the London Underground, illustrated in Pottery Gazette, 1923.

declining however by the early 20s, and a lot of fired but undecorated pieces remained in the factory. Arthur Shorter's two sons, Colley and John Guy, who had taken over the business when their father retired, also in 1920, acquired the Newport Pottery Co. They allowed Clarice Cliff to experiment on some of the undecorated shapes in the works. At this time she was also attending evening classes at the Burslem School of Art under Gordon Forsyth. Forsyth was an advocate of hand-painting as a means of decorating and a strong critic of the current lithography. He believed that good hand-painting could greatly improve the standard of design but he did not approve of Clarice Cliff's work. To him, it seemed that she was making use of the superficial aspects of what was being perceived as 'modern art', without understanding any of its principles.

Nevertheless, when her experiments were brought to Colley Shorter's attention, he felt it was worth the risk of getting his salesmen to test the market. There was evidence that these could become a new line in art ware, based on novelty and their overt hand techniques.

This 'Bizarre' ware sold reasonably well, partly due to one of the few concerted publicity campaigns actually mounted by a pottery manufacturer at this time. One of the first advertisements for Wilkinson's which makes reference to the new 'Bizarre' ware appeared in February 1928. These first pieces were the old shapes decorated by girls who had had only rudimentary training by Clarice Cliff in applying simple designs and banding. The spring advertisements and the first showing of the new style at the British Industries Fair in March were intended to prepare the retailers. The reviewers of the Fair thought it was rightly named 'Bizarre'. When sufficient stock had accumulated the range was launched in the Autumn. Sales were promising and the capacity for producing it expanded. Gradually new designs were introduced and much more extreme shapes developed. Special display material was issued to shops, particularly a curious donkey-like animal, made up of cups, plates, saucers etc. and called 'Bazooka'. Demonstrations of the decorating processes were also given in department stores by girls from Wilkinson's.

This marketing approach may not seem so unusual today, but what made it remarkable at the time was that the pottery industry, even by comparison with other contemporary industries had shown very little consciousness at all about advertising between the Wars. Because they assumed that the received knowledge handed down from one generation to another, supplemented by responses from wholesalers and retailers, was sufficient market research, producers had little direct evidence of retail demand. Information was always filtered through middlemen. It was also assumed they had little means of influencing public choice. All their advertising except for major well-established firms like Wedgwood, Minton, Worcester etc. was to the trade buyer. This was one of the reasons why pottery failed to hold its place in the market when confronted with competition from newer consumer durables which were actively promoted and advertised.

In America this continuous need to expand and create turnover in the market was much more thoroughly understood and accepted. There, unlike in Britain, it was normal for the manufacturers to provide point-of-sale publicity.

The sale of 'Bizarre' ware showed that successful sales could be achieved by this means but the lesson was not generally learnt. Individual stores advertised their china and glass departments, but the manufacturers' names were often not included.

The only other medium sized firm that developed a conscious marketing policy was Shelley China. Since the 1880s the firm of Wileman & Co Ltd. had as a partner J.B. Shelley and employed his son Percy. The firm had mainly been involved in production of ware for America, and Percy Shelley visited the Chicago Exhibition in 1893 in order to study the requirements of the market. It was at this time that the name 'Foley China' was adopted to mark this export ware. In 1896 Percy Shelley built a new factory to produce hand-painted earthenware art pieces. These were marketed under the name of 'Intarsio' wares and were designed by Frederick Rhead. In 1901 Walter Slater became art director, having studied under his uncle John Slater at Doulton. He continued to produce the finely painted tea and dinnerware designed for America but, in response to the uncertainty of exports and the high American tariffs, more effort was put into the home trade. The trade mark 'Foley China' proved to be impossible to register for use in Britain (even though it had been used by Wilemans for export) as E. Brain Ltd of Fenton had already registered it. Therefore the name 'Shelley China' was registered instead, and a publicity campaign was mounted to make sure that the public and buyers recognized the company's continuing production.

The art ware begun under Rhead was developed by using glazes which 'ran' together. Combinations of bright colour could be applied with

little hand skill and then the chance element involved in the firing made each unique. The results appeared to have the qualities of colour, individuality and immediacy seen as typifying modern art.

K.J. Shelley, Percy Shelley's third son, took over the finances of the firm after doing a degree in business at Birmingham University, and he persuaded his father that an active marketing policy was needed, using advertisements to create an identity for the firm. They would create demand and promote ceram-

Toilet and tableware made by the Newport Pottery Co. Ltd. Hand-painting was developed for these floral designs before Clarice Cliff introduced her 'Bizarre' ware on Newport Pottery shapes.

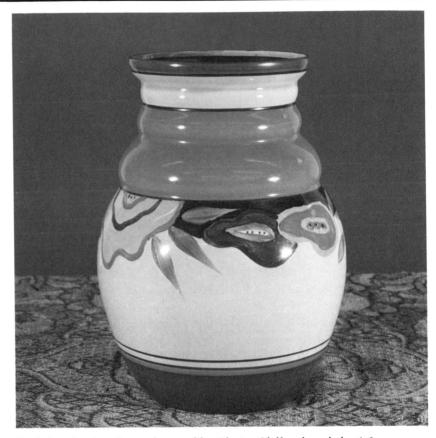

Early hand-painted vase designed by Clarice Cliff and made by A.J. Willkinson Ltd, c.1929.

ics as fashion goods in the way the Americans were doing. Consequently when their new 'Vogue' shape was introduced at the beginning of 1931, its name linked it with high fashion and its geometric shape and stylized patterns were advertised as 'of the modern age'. The campaign was launched in women's magazines and the national press, while brochures

with contemporary graphics were widely distributed to the point-of-sale outlets.

Most firms however, still chose to believe that they simply responded to public demand rather than in any way influencing it. This belief was a crucial factor in the subsequent arguments about the viability of producing modern designs.

By 1928 the Art Section of the Ceramics Society had faded out through lack of interest. Gordon Forsyth described it as 'a still-born child left on some-one else's doorstep'. The old debates about education seemed no longer crucial as growing unemployment was producing a surfeit of skilled labour in place of the former dearth, and concern was with survival rather than debate. The number of businesses becoming bankrupt was increasing. Even the Worcester Royal Porcelain Co. was put in the hands of the receiver in 1930. It survived, needless to say, but it showed that even the major makers of high-priced ware were suffering. The Wall Street Crash of 1929 was partly to blame because it affected the sale of expensive goods, such as the elaborately decorated dinner and service plates, which firms like Worcester had sold in America.

Questions of education and design were however, being addressed elsewhere. An awareness of the developments of modernism on the Continent was beginning to grow among the designers themselves, through articles in non-pottery journals, particularly the Architectural Press. In 1930 the Society of Industrial Artists was formed. It was intended to secure a status for artists working in commerce and industry and to promote education in those areas. One of the first regional branches to be set up was in North Staffordshire in August 1932. This then became the major forum for debates concerning modern art as they affected the pottery industry.

The first and chief problem that became apparent was the confusion surrounding the definition of 'modern art'. Initially many manufacturers and also designers saw this as simply another style, derived from superficial aspects of what had been seen at Paris in 1925 and other Continental trade fairs since. It featured forms derived from Cubism and Futurism and the colour of post-impressionism combined with both exotic and mechanical motifs, which French designers had welded together and used to produce expensive hand-made pieces. The translation of this to batch production pottery, retaining the impact of colour and motif while substituting for craftsmanship blatant signals of hand-painting, had produced the 'Bizarre' and Shelley pieces.

Both of these served a market stimulated by advertising, but many manufacturers argued that this was merely a variant in a range of decoration and that their existing buyers showed no evidence of demanding it. The argument of 'we only design what sells' was paramount. Those

'Crocus' pattern on 'Bizarre' shapes by Clarice Cliff, made by A.J. Wilkinson Ltd, c.1930.

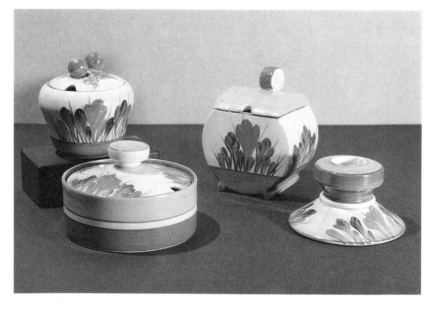

who felt obliged to excuse their position simply blamed the public for being 'uneducated'.

While modern art was being construed on this basis the arguments became endless and pointless. In these cases it was the French decorative work which was primarily cited as the exemplar. This was perhaps inevitable while the concept under discussion was modern art not modern design. Paris was certainly seen as the centre of the avant garde in the fine arts. But there were those for whom modernism in design meant the International Style that was being developed in the German Bauhaus School and by Le Corbusier.

One of the reasons why the emphasis in Britain was still being placed on art in industry was that this was a period when the livlihoods of many fine artists were under threat from the depression. The devaluation of the pound by the National Government in 1931, while it brought a brief respite to trade by making British exports cheaper, had also made life too expensive for many British artists living abroad and they had returned home. The sales of paintings and drawings were also affected and a number of artists became more involved in commercial design. New patrons such as Frank Pick at London Transport began to commission posters from them. The motives of these artists were not entirely pecuniary.

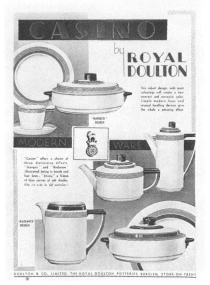

An advertisement for 'Casino' dinnerware by Royal Doulton, 1934, showing the 'simple, modern lines'.

There were those who genuinely sought a wider audience for their work than the limited category of the gallery-goer, and who believed they could contribute to the making of a better environment for a greater number by becoming involved with design.

Some of the older generation like Frank Brangwyn, had worked across a range of media as well as his better known paintings. It seems that his collaboration with Doulton began when, in conversation with some members of the D.I.A. who were complaining about the lack of good design, he agreed to design a series of

household goods, furniture, carpets etc. C.J. Noke the Art Director of Doulton, who tended to be irritated by the carping tones of the D.I.A. agreed to collaborate and in 1930 Brangwyn's designs for tableware were launched.

They were made of earthenware as Brangwyn had wanted them to be available to those on low incomes. In fact they were sold very cheaply, but not mainly to those for whom they were intended. Each piece was hand-decorated and different, the signs of the modelling left apparent. Contrary to intentions they appealed not to the working classes but to those of the middle class who were developing an educated taste for studio pottery. They continued in production until the Second World War but never sold in large quantities. They were, however, approved by the D.I.A.

A similar experiment was tried by E. Brain & Co., producers of Foley China, in 1932. The idea was to invite a dozen artists to design decorations for ceramics and bring some new life to them. The original dozen were people who had had some experience of design but in 1933 it was decided to increase the number to 27. Many of the newcomers had only previously been involved with fine art. The artists produced drawings for the designs and the firm had to adapt them for production. As they admitted, changes had to be made on tech-

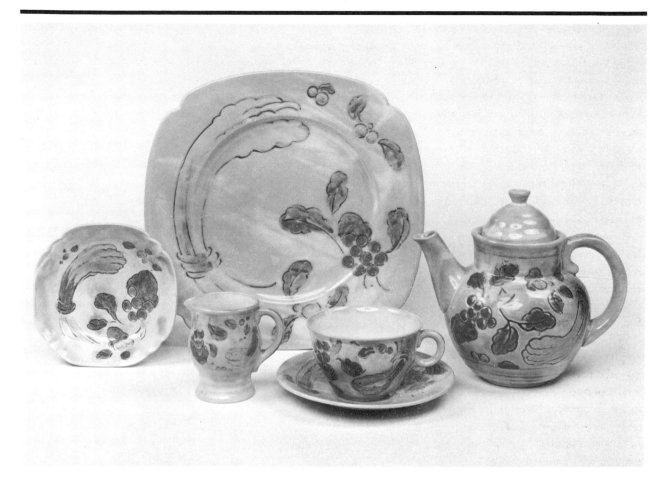

Teaset in 'Harvest' pattern by Frank Brangwyn in collaboration with C.J. Noke and made by Royal Doulton Ltd. The teaset was in production between 1930-40.

nical grounds and because some would have been impractical in terms of cost. Because the original intention was to make these available at reasonable cost, the firm of Wilkinson's also agreed to put the designs onto earthenware to complement the Foley China set. Clarice Cliff was involved not only as one of the artists in her own right but because it fell to her to adapt the designs for hand painting on earthenware. Both sets were exhibited in November 1934 at Harrods store. They were acclaimed by the critics generally, but even Nikolaus Pevsner who commended the idea in his *Survey of Industrial Art* and cited it as evidence of the growing demand for 'distinctly modern decoration', had to admit that 'in purchasing such first editions (as they were called) there might have been a certain amount of snobbery'. Clarice Cliff recalling it in 1951 made her feelings plain: *"It was a list of names of very prominent people, almost all of whom were recognized then as crea-*

tive in the 'modern' school of thought. I remember what headaches we had over the reproduction... but sad to relate, from a commercial point of view i.e. sales to the public, it was so disappointing that it was the closest thing to a flop that, I am glad to say, I have ever been associated with."

Pevsner also likened this to Josiah Wedgwood's employment of artists such as Flaxman in the 18th century. To counteract the slump, Wedgwood again hoped to stimulate the upper regions of the market by commissioning designs from free-lance artists. The sculptor John Skeaping had already done work in 1926 and in the early 30s Rex Whistler produced 'Clovelly', reflecting the taste for picturesque English landscape and Eric Ravilious produced designs such as 'Travel' and 'Agricultural Implements' in the style of his woodcuts. In each case lithography was used to reproduce the original textures.

Early in 1931, the year after the S.I.A. was formed, the then Labour Government set up through the Board of Trade a Committee on Art and Industry under Lord Gorell (The Gorell Committee). It included artists, craftsmen, architects etc. plus the director of the Victoria and Albert Museum and the Chairman of the British Institute of Industrial Art. Its brief was similar to that of the B.I.A. and it was viewed by industrialists in

'Clovelly' designed by Rex Whistler for Wedgwood creamware, c.1932.

Below: Alphabet mug designed by Eric Ravilious. Earthenware with transfer decoration, c.1939, made by Josiah Wedgwood & Sons Ltd.

Above: Plate designed by Eric Ravilious for Wedgwood. Although designed in the 1930s some of Ravilious' designs were not produced until after the War. Ravilious died in 1942.

much the same light. It appeared to represent Government interference in free trade. When the question of renewed funding for the B.I.I.A. had been discussed, many were against public money being spent on an enterprise which did not have industrial support. A similar attitude to public spending had already curtailed research being done by Professor D. Mellor and Bernard Moore at the College in Stoke into hard-paste porcelain. Their grant was cut because of complaints about tax-payers' money being used to fund industrial research. Most manufacturers were still advocates of Free Trade but due to the monetary crisis in 1931 the National Government was returned on a protectionist policy. While restrictions on 'dumping' were favoured, any further intervention was strongly resisted. The pressure being exerted on other, more staple industries to rationalize, fix prices, standardize etc. was seen as positively inimical and if anything, hardened resolve behind indepen-dence and competition. The only voluntary attempt at co-operation had been the formation of the British Pottery Manufacturers Federation in 1918 to fix prices in an attempt to avoid the price cutting wars and wage reductions of the pre-war era. This had worked during the short re-stocking boom but by 1921, as soon as there was falling demand and increased competition, firms began breaking the price codes and the Federation could do little to stop it.

The climate was therefore not auspicious for the kind of arguments being put forward for modern design by the pioneers in Germany and elsewhere. In their view, new attitudes were required to the treatment of material, a re-thinking of all conventional forms and an emphasis on function and form at the expense of decoration.

In 1931 Jack Pritchard, Wells Coates and Serge Chermayeff visited the Bauhaus in Dessau. There they found an educational institution which in its formative years had been dominated by Walter Gropius, who had written in 1926 in his *Principles of Bauhuas Production*: *"The Bauhaus workshops are essentially laboratories in which prototypes of products suitable for mass-production and typical of our time are carefully developed and constantly improved."*

Ceramics as a subject, though,

had only been included in the syllabus in the period while the Bauhaus was in Weimar, a period when the focus had been on bringing together art and design and on teaching craft processes as a basis for later design work. It is interesting that when the emphasis under Hannes Meyer and subsequently Mies van der Rohe was shifted more specifically to design for mass-production, ceramics was discontinued. It was as though here too there was a tacit belief that the nature of the material and its methods could not be entirely brought within the sphere of industrial production. Nevertheless some designers trained at the Bauhaus went on to produce marketable designs. Marguerite Friedlander, Gerhard Marks, Otto Lindig, Wilhelm Wagenfeld and others had designs produced by a number of firms, particularly the State Porcelain Factory at Berlin.

The British designers when they returned from their visit were deter-

Tureen and coffee pot designed by Wilhelm Wagenfeld for Porzellanmanufaktur Furstenberg, 1934.

Teaset designed by Marguerite Friedlander for Staatliche Porzellanmanufaktur, Berlin, c.1930.

mined to spread the word about what they had seen. Serge Chermayeff gave a lecture to the newly formed North Staffordshire branch of the S.I.A. in November 1932 on modern design entitled 'A modern designer's point of view'. This was part of a series which had revolved mainly about the concept of modern art in its modernistic Art Deco sense. A few of the protagonists, notably Gordon Forsyth, had subscribed more specifically to a view of modernism more in line with that of the European International Style. Forsyth in a previous attempt to bring some order to the chaos surrounding the definition of modern art had typified its principles as a concern with new materials expressive of the age, mass-production, restraint and simplicity, and above all in economy of means. He stressed that it was analogous to an international language expressing the spirit of the age. In relation to functionalism, to him this was a question of morality. He compared it to Art Nouveau with its lack of truth to materials saying that modern art, unlike Art Nouveau, was rational, orderly and clear-cut thinking in material. Modern art was not an affectation – a cultural pose – but honest, clear and purposeful. This interpretation clearly owed a debt to

Ruskin and Morris but then so did the Bauhaus as an institution. It was perhaps a clearer statement than had yet been heard in the context of the Potteries and he followed it with a more immediate and practical reference to the current situation. He stressed that the necessity for economy was something that was very real in Britain – as it was in Germany and elsewhere – and that there was no doubt that they would have to face up to the question of economy of ornamentation for it was impossible for them to run away from it. Chermayeff was able to build on this groundwork. He reiterated many of the same points while stressing the relationship between form and colour. They were, he said: "of *a*

thing not on *it. For example, if you want to introduce a cheerful note of yellow into a tea-set you should have a yellow tea-set, or yellow insides to cups and saucers; you should not put on each cup and saucer a bunch of daisies or a canary"*. Simplicity was the essence. If a job required, when finished, the addition of ornament, this could only mean that it had failed in the first place. Elaborate dust-collecting objects of all kinds were useless in the new order. Those things that were made should be essentially the products of the machine age and modern designers should embrace machinery as a heaven-sent opportunity for multiplying good design and making it accessible to all. In the concluding stages of his talk,

Chermayeff urged that a new modern style of design should be approached by a freshness of outlook and the abandonment of that sentiment for tradition which led to the survival of old forms.

Whether or not the designers who heard statements such as these accepted the ideology of modernism, their immediate responses were of a highly practical nature. Whatever the long-term advantages of thinking in this way, the very high level of unemployment in the industry was uppermost in their minds. If the industry began to produce fewer shapes and eliminated most forms of decoration would not the jobs of skilled craftsmen such as engravers and model-makers – and also, incidentally, designers – be under threat? Even the manufacturers used this argument against modern design on the grounds that they had a moral obligation to retain jobs for their work-force. In the sense that the industry was not organized on a scale that allowed such an approach to be economic, and could not be so without large capital investment, this was a genuine reason for objecting. Another less tangible, though no less deeply felt, objection was the association of these ideas with Germany, always regarded with suspicion since before the First World War. The more conservative of those involved associated modernism with the Weimar Republic but then argued that events such as the closure of the Bauhaus and the growing emigration of modern artists was simply proof that modernism was not successful. Rather than admit that these changes took place as the result of positive political discrimination, the British trade assumed they were due to market forces and argued that a supposedly neutral public had indicated that there was no demand. The increase of imports into Germany from the mid-30s onwards of English designs of a highly traditional nature was taken as re-inforcement of that idea. Modernism was simply a German aberration.

Some of those who would subscribe in principle to many of the ideals of the Modern movement, though remaining doubtful about how its extreme solutions could be put into practice in Britain, began to look at Scandinavian design for interesting examples. This happened sporadically during the 30s and much more when events after the Second World War increased the problem.

The Stockholm exhibition of 1930 aroused some interest just at the moment of debate and an exhibition of Swedish Industrial Art including pottery and glass was organized at Dorland House in London in 1931. Scandinavian ceramics had been seen at Paris in 1925 and New York in 1927. Public knowledge of Swedish ceramics was fairly minimal (though it had been reviewed in publications like *The Studio Yearbook*), but those connected with the ceramics trade had followed developments partly through A.S.W. Odelburg of the Gustavsberg firm. He had been a member of the English Ceramic Society since it started and frequently visited to give papers to both the Technical and Art Sections. In 1920 he had delivered a lecture outlining the attempts to improve modern design in the Swedish factories.

Design at Gustavsberg in its early days had been very dependent on English models but the desire for a national style at the end of the 19th century which gave rise to 'National Romanticism' had led Oldenberg's father to employ a fine artist Gunnar Wennerberg to produce designs based on national flowers etc. In 1912 the Society of Swedish Industries agreed to collaborate with the Svenska Sloidforeningen (Swedish Society of Industrial Design) to try to improve standards of design. In 1914 an exhibition in Malmo took place known as the Baltic Exhibition and in its report of 1915 the Society of Industrial Design sharply criticized the Swedish ceramics in comparison with those of Denmark. A defence was published in the *Swedish Technical Gazette* under the heading 'Art and Industry: A Rejoinder'. In this article it was urged that the task of Swedish potters was

to democratize artistic ceramic products so as to bring them within reach of all, whereas the Royal Copenhagen pieces that had been praised were only bought by museums or wealthy art lovers.

The immediate result was an invitation to manufacturers and others interested in the problem to attend a general meeting to talk things over. This meeting is credited with having brought about a change of thinking in the Swedish Society of Industrial Design. The organization was first set up in 1845 to check the decline of handicraft and industrial art resulting from the dissolution of the guilds and from large-scale industrial production. It considered itself the guardian of Arts and Crafts. It had been regarded as a kind of academy for practical arts and crafts and the small hand-work industries which continued to a greater extent in Sweden than in England. Gradually, however, many of its functions had been taken over by other societies and institutes.

After the re-organization in 1915 the Society had recognized that the socially important industries were those large units involved in mass-production and had turned its attention to co-operating with these. Its functions included a bureau to find employment for artists and designers within industry and arrange exhibitions etc. In 1917 the Society approached the ceramic industries and invited them to participate in an exhibition of cheap and useful articles for the homes of people of modest means. Rorstrand and Gustavsberg accepted the invitation and both engaged artists from the Society's bureau to design for it. Gustavsberg employed Wilhelm Kåge who designed a dinner set which became known as the 'set for the working class'. The price was not as low as intended and, as with so many other similar ventures, it was mainly the educated young middle-class who bought it. It remained in production however, till 1940.

The system adopted in Gustavsverg and other factories in Sweden was that designers not only created utility ware for the general market but also devoted some time to making hand-craft and studio ware which sold as art ware and contributed to research. In 1919 the Society of Industrial Design in Sweden, in agreement with the makers, started issuing a 'seal of approval' for goods it considered designed in accordance with its standards. This was a practice later adopted by the Design Council in Britain.

In the Paris exhibition the competent, restrained forms of the Swedish ware with their limited hand-painted decoration were commended rather coolly for their practicality in the reviews. Gustavsberg's designs were described as 'specially designed for hard, everyday use', and of Rorstrand the reviews said that 'they present an interesting collection, though the bulk of their exhibit is confined to useful everyday ware.' Clearly they were not considered to be as exciting or appealing as the Royal Copenhagen high-priced ornamental pieces, which were obviously felt to be more in keeping with the rest of the exhibition and were glowingly praised.

By the 1930s, however, those restrained qualities and the concentration on useful tableware were better attuned to the economic climate. Kåge's first oven-to-tableware design for Gustavsberg called 'Pyro' was not revolutionary, but it was useful. It was ideally designed to fit into the large number of new apartments being built to solve the acute housing problems in Stockholm, where living space was very small compared with other countries and where economy of space was crucial. The designing of multi-purpose shapes and stacking pieces at a reasonable price was as much the result of commercial sense as ideology. 'Praktika' which Kåge designed in 1933 and in which he produced a more extreme solution, including all the more austere attributes of functionalism, was not nearly such a success.

This emphasis on the less extreme modern forms and the retention of a limited amount of decoration can be seen reflected in English design in the

'Pyro' designed by Wilhelm Kåge for the Stockholm 1930 Exhibition and made by Gustavsberg Ab.

formats together. In 1933, therefore, she began to design shapes incorporating her ideas about the modern design she had heard Gordon Forsyth and Serge Chermayeff discussing in their recent lectures at the S.I.A. The superficial decorative interpretation of Art Deco motifs was replaced by design for (albeit limited) mass-production, attempting to emphasize simplicity and restraint. The complete abolition of decoration was not conceded. (Susie Cooper had been one of those who raised the question of unemployment.) The type of market she was aiming for amongst the buyers of middle-priced earthenware still required a degree of colour and motif. For them, the austerity of work like that of Germany or Wilhelm Kåge's 'Praktika' was far too anonymous.

The lack of awareness which the critics of industrial design seemed to show with regard to the actual preferences of the public continued to irritate both the manufacturers and designers. The Gorell Report on Art and Industry included as an appendix a memorandum from Roger Fry, a member of the committee, which summed up their attitude. 'Despite the excellent work of some firms', Fry said, 'my own impression of the situation today is that our manufacturers are all at sea in the matter of design .. They have lost contact with educated taste'. This comment was taken hard

30s. Susie Cooper particularly was a product of Gordon Forsyth's teaching and exemplifies the difference between his reading of modernism and that of Clarice Cliff.

Susie Cooper first worked for A.E. Gray, painting lustre decorations, and became involved in that firm's work for their Paris exhibit in 1925. Both before and after this she was a protégée of Forsyth who also designed for Gray on occasions. The

first pots that she produced at her own works, which she established in 1929, were decorations on bought-in shapes. The colouring and patterns were bright, stylized flower motifs and combinations of wash-bands and lines. Some successful exhibits at the British Industries Fair gained her orders but this first work was primarily design for decoration. She became increasingly aware of the need to design both the shapes and decorative

in the Potteries. Its assumption that 'educated taste' constituted an ideal which should dominate all other class tastes was arrogant and elitist. But this pursuit of an 'Ideal' pervaded ideas of modern design. A form of idealism was the philosophical extension of the concept of type-forms. The proposition was that certain forms could get so close to the perfect solution in design that they could transcend specific historical periods or geographical and cultural contexts. Once this was achieved, if it were possible, they would become the right designs for all people at all times – it was the universal solution, not the particular one, which was being sought.

This is evident in the choice of

'Praktika' earthenware dinner service designed by Wilhelm Kåge to exemplify functionalism. Produced by Gustavsberg Ab, 1933.

Decorative plate by Susie Cooper in the early days of the Crown works. It uses tube-lining and enamel for its asymmetric design.

Below: plate with wash-band and lithographed centre motif, together with a bowl and saucer in the 'Crayon lines' pattern made at the Crown works, c. 1933.

examples used to illustrate key texts on design at that time and the way these examples were described. Both Nikolaus Pevsner and Herbert Read were writing in the mid-1930s about design, Pevsner in his *Survey of Industrial Art In England* and Read in *Art and Industry*. The examples they use of design are very similar. Some of the most frequently cited are examples of Wedgwood's original creamware shapes, designed with the first introduction of factory techniques in the 18th century, of which some were still in production and others had been revived in the interwar years. These were held up as being modern, because they embodied modernist principles and came close to being ideal types. Mention was also made of the designs Wedgwood had commissioned more recently from Keith Murray, a young New Zealand architect. In addition to bringing in new decorative designers like Ravilious etc. they had asked Murray to design some ornamental ware and short sets. This he had done, emphasizing their mechanical means of production by positively stated turned lines and forms based on references to the engine-turned fluting found on the original Wedgwood neo-classical wares. The self-referential nature of the form and its machine sources identified it as modern in Read and Pevsner's sense.

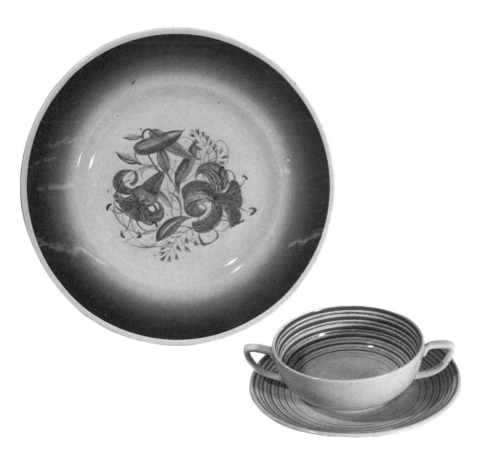

Other designs favoured by these two writers were William Moorcroft's 'Powder-blue' lines. These had been put into production in 1913 as the only major range of tableware by a factory otherwise noted for their ornamental pottery. Another utilitarian example that was commended was T.G. Green's 'Cornish Kitchenware', a ubiquitous design put into production in the early 1920s and derived from traditional blue-dipped ware adapted for factory production.

Nikolaus Pevsner's surprise at the lack of plain, undecorated ware was partly due to his relatively recent arrival from Germany where he was familiar with the undecorated porcelain shapes of Arzberg and Berlin.

Herbert Read was a member of the Unit 1 Group, formed in 1933 whose professed aims were to consolidate the ideology of modernism and act as a defence against the growing tide of nationalism. Its concept of the future involved planning and rationalization, and rational solutions were what it sought in design. In the preface to *Art and Industry* Read states his belief that, *"The work of art is shown to be essentially formal; it is the shaping of material into forms which have a sensuous or intellectual appeal to the human being."*

The normal or universal elements are the objective. He continues, *"Aesthetic values are absolute or universal values to which an object,*

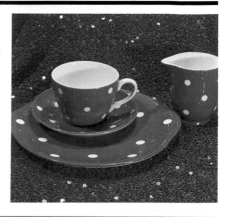

'Blue domino' produced by T.G. Green & Co. Ltd, introduced in the mid 1930s in an attempt to cash-in on the success of the Cornish kitchenware – it was never as successful.

Below: Coffee set with a 'Moonstone' glaze designed by Keith Murray for J. Wedgwood & Sons Ltd, c.1934.

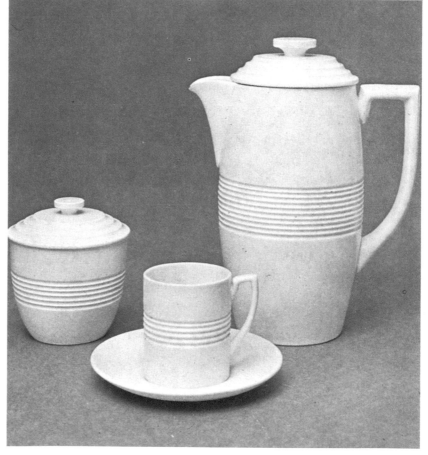

Beer mug from a set designed by Keith Murray for Josiah Wedgwood & Sons Ltd. Cream earthenware, c.1934.

Below: Cornish kitchenware produced by T.G. Green & Co. Ltd from the early 1920s. The range began with the storage jars and jugs and expanded over the years to include tableware as well.

restricted by its function to a particular form may approach; but by very reason of its particularity, cannot inevitably assume."

The establishment of these examples in critiques made little impression on industry at the time. Such writing remained part of a theoretical debate at a level divorced from the workings of the average designer. It was not until after the Second World War, that circumstances brought about by direct Government intervention gave unprecedented opportunities for critics to influence design policy. Meanwhile, the simplification and streamlining of shapes were influenced more directly by economic necessity than by academic rhetoric.

The exhibition held at the Dorland Hall in 1933 was a result of the Gorell Committee report and was designed to show to what extent the British industrial system could turn out well-designed goods suited to modern conditions. It was privately organized but had the approval of the Government, the B.I.I.A. and the S.I.A. It was arranged in a series of sections organized by designers such as Chermayeff, Wells Coates etc. Goods were selected for exhibition and ceramics shown included Wedgwood self-coloured wares, Poole pottery from Carter, Stabler & Adams, works by A.E. Gray and Susie Cooper. It was dismissed by the pottery press as entirely unrepresentative.

The exhibition held in 1935 however, at the Royal Academy, epitomized the new mood. Even some former adherents of modernism were turning away and there was an evident growth of that nationalism which Unit 1 had set out to oppose. The exhibition was sponsored by the Prince of Wales and organized by John de Valette, a convinced nationalist. In a lecture to the potters in April 1934 prior to the exhibition, he made his feelings and those of the other organizers of the exhibition clear. Modernism, he argued, had culminated in barren rooms and objects devoid of all ornamentation. He did not recognize aspirations to beauty in pure form but exhorted the industry to bring beauty back once more into what had become 'mere decent emptiness'. He vehemently criticized 'Teutonic mechanized conceptions' and advocated only 'plain English design'. He even had the temerity to criticize Josiah Wedgwood for having produced mechanized un-English shapes. It was necessary, he said, to put all designing energy into supplying not just the material necessities but also cultural ones.

When asked what constituted 'Englishness' in acceptable objects, Valette dodged the issue by saying that they would take only what was 'best' in the judges' opinion, *"a few things which contain within them something real and fundamental and which had at their roots something English"*. What that was, was to be left to the personal interpretation of the judges.

What was in fact selected was a varied collection of designs many of which had been in production for some years and undoubtedly owed something to the Paris Exposition of 1925, plus some of those wares such as Murray's beer mugs which were being commended elsewhere for their austerity. The main range included was the one decorated by artists for E. Brain and A.J. Wilkinson. In general the committee approved the standards of design. The imagery of Dame Laura Knight's 'Circus', John Everatt's 'Cutty Sark', and Ernest Procter's 'The Hunt' were all considered to be sufficiently indicative of English design. They could be described as nostalgia for the nautical and rural coming together with an increasing interest in popular culture, where this last was filtered through romantic whimsy.

In the American consumer boom of the 20s, American potters had been tempted to move away from long runs of a few patterns in domestic ware as they tried to compete with other products for the family budget. Economic reality as well as critical argument had urged the production of the 'artistic'. Until 1929 shapes and decorations were proliferating, but American factories had concentrated when they were built on the organization of the plant and its technical equipment – they made extensive use of tunnel kilns, trucks, spraying machines capable of glazing 1,200 pieces per hour, and other labour-saving devices. The most important members of the factory were the ceramic technologist and the mechanical engineer, but before the 20s few factories employed their own designers.

In firms often lacking a designer, attempts were made to modernize the shapes and, as decals were the major decorating process, producers required geometric stylizations from their traditional flower painters to meet the demands for modern design.

Department stores were the main outlet for middle and high class goods but often insisted that they had exclusive rights to designs within a certain area. Designing in American factories was much more closely connected with the distribution points, and communication between stores and manufacturers was given a lot more importance than in Britain. At this time much that was being described as modern had those superficial aspects of Art Deco derived from Paris and Eastern Europe.

Once design was recognized as a necessary adjunct to industrial production, though in many cases reluctantly, the role was interpreted as being both technical and artistic. The tendency in Britain was still to see the

Right: Hot water jug from the 'Powder-blue' range designed by William Moorcroft and put into production in 1913. It continued to be made for over 50 years.

designer as an artist quite separate from the technician, who was usually the works manager. Frederick Hurten Rhead, art director and designer for Homer Laughlin China, gave it as his opinion in 1937 that, *"the artist interested in ceramic creative development could go much farther if, in addition to his decorative work, he paid due regard to organization, practise and procedure."*

This view of the designer as being concerned with both technical and visual problems together, was closer to the role envisaged by advocates of modern design. More importantly it was the role it was necessary for the designer to adopt, given the methods of production operated by the industry. Such people in Rhead's view would be essential as art directors in the future, but he also subscribed to the idea that it was possible that a competent designer, if he had the knowledge of markets and merchandizing methods, need not possess any direct practical knowledge as a potter or ceramicist. This, he said, had been demonstrated many times by several American organizations which had made a speciality of industrial design.

Left: Cane coloured 'Bourn-vita' hot drink set. Produced especially for Cadbury's by Wedgwood as a promotional line, c.1931.

This growth of the professional industrial designer in America began to emerge after the recession of 1927. The Wall Street Crash of 1929 and the Depression forced many small firms into bankruptcy, while take-overs and amalgamations concentrated production into larger units. The depression then forced these into further competition. Many of the industrial designers came from commercial art backgrounds and were able to liaise with sales outlets, analyze markets and create whole packages for firms, as Rhead had said, without knowledge of the making processes involved.

One of the notable designers who worked for the bigger firms, was Walter Dorwin Teague, whose early work for Kodak had been extremely successful. By 1934 his office was well established and the firm of Taylor, Smith and Taylor, who concentrated mainly on producing china and earthenware decorated with underglaze prints, commissioned him to produce a modern line for them. This resulted in 'Conversation'.

Russel Wright's aims as a designer were market oriented but combined with an Arts and Crafts respect for materials. He aimed to produce a series of simple functional designs possible for mass-production and available to a wide range in the market. After studying art at the Cincinnati Academy and law at Prince-

"QUALITIES OF THE CRAFTMAN'S WORK NEWLY ACHIEVED IN MASS PRODUCTION"

WELLS DINNERWARE

"THE RETURN TO THE CRAFTSMAN'S IDEAL OF BEAUTY IN EVERY PRODUCT FOR DAILY USE—WHICH WAS DISCARDED WITH THE INTRODUCTION OF MACHINES—HAS BECOME A PRESENT UTILITARIAN NEED"

THE HOMER LAUGHLIN CHINA COMPANY
NEWELL, WEST VIRGINIA

Advertisement for Wells dinnerware by Homer Laughlin China Co., illustrated in The Crockery & Glass Trades Journal, *1930.*

ton, Wright worked on stage designs between 1924 and 1931. By 1930 he had established his own works to produce informal serving accessories, mostly made of wood and spun metal. He and his wife Mary first conceived the idea for the tableware which was to be part of the 'American Modern' series in 1932-33 but it took three years to find a producer. It was finally put on the market by the Steubenville Pottery which was rescued from the hands of the receiver. Although not the cheapest, it was reasonably priced at between

$6.95 and $7.95 for a 16-piece set. The pieces were based on simplified shapes which appeared soft and fluid, Wright's response to the clay material. The holloware showed evidence of the 'streamlining' being used elsewhere in transport design and the flat ware was the rimless coupe shape. The single colours were applied by spraying the glaze giving them a speckled effect. The shapes and glazes were designed for the full use of mechanized processes.

Wright subsequently designed lines for firms such as the Sterling China Co. (restaurant ware); Paden City Pottery 'Highight' line; Iroquois China Co.'s 'Casual' china in the 1950s and the Harker Pottery Co.'s 'White Clover' just after the War. In 1941 he was awarded the American Designers' Institute medal for the best ceramic designs.

The styling features developed to signify speed and efficiency in cars, aeroplanes and new consumer products were transmitted to the older, more static forms of tableware, but the work of most professional designers was directed to the newer industries, and the larger proportion of ceramic designs produced in the 1930s came from the in-house designers – the art directors and designers who had a full knowledge of the craft and techniques, as Rhead said (being one himself).

Immediately after the Crash, when small firms were being taken over and trade was very uncertain, the former proliferation of shapes and patterns was seen to be exacerbating the problems. Lines were scrapped and decorating reduced. The trade journal *Crockery and Glass* published an interview with Richard F. Bach the Director of Industrial arts at the Metropolitan Museum under the title 'Is the Depression raising decorating standards?'. Bach, along with other critics of design believed that it was, in that a breathing space was being provided for re-assessment and a more constructive approach to design for mass-production might follow.

In 1937, under Roosevelt's National Recovery Act, a scheme was put forward for the pottery trade in America in which no goods were allowed to be sold under cost, the costs having been ascertained by a joint committee of workmen and employers with the aid of accountants. There was also to be a moratorium on shapes lasting a year.

This prompted in-house designers to consider the best ways to economize in production. While shape was limited and single colour treatments most economic, the quality and range of colour could be developed.

Frederick H. Rhead at Homer Laughlin designed what was to become one of the most recognizable ranges of the time with his 'Fiesta' ware. F.H. Rhead was one of a prolific family most of whom were involved in the pottery business either in America or Britain. His father, Frederick A. Rhead, studied under Marc Solon at Minton's, designed for Wedgwood and then spent most of his career as Art Director for Wood & Sons Ltd. Frederick Hurten was born in Hanley, North Staffordshire, and after various apprentice jobs became Art Director of the Waddle Pottery before emigrating to the United States. He worked at a number of potteries between 1904 and 1917, several of them in California, including his own, the Rhead Pottery in Santa Barbara. There, he began the experimenting with glazes which was to be continued in his later work for Homer Laughlin. In 1917 he closed the pottery and joined the American Encaustic Tiling Co. of Zanesville as Research Director. His brother Harry G. Rhead was also involved in tile production in Zanesville.

In 1927 he became Art Director of the Homer Laughlin China Co. of Newark, New Jersey, and remained there till his death in 1942. He developed the reputation for being outspoken and often controversial in both the American and British press. It was in the last phase of his career, however, that he designed 'Fiesta' which was to become a notable success for the company and to be

imitated by others. The pieces were relatively simple, designed for more informal styles of dining. Many of the shapes could be used for several purposes. The thinking behind the forms had the practicality of some of the Scandinavian designs, but what set it apart and sold it were the intensely bright colours. These could be mixed and matched, either by the factory when making up sets or by the purchaser. It was, in this, a forerunner of the 'Harlequin' sets of the 1950s.

It was designed after extensive technical experiments in 1936. Rhead had persuaded Homer Laughlin to equip him and his design staff with an extensive laboratory-cum-studio for research and development. The biggest achievement was 'Fiesta red' as it became known. It was a bright, true solid scarlet, the first time such a glaze had been used on mass-produced ware. One of the problems was that it needed its own kiln for firing because the colour could affect other ware fired with it. However, it was put on the market and proved extremely popular, so much so that imitations were quickly made. The design was patented in 1937 and 'Original Fiesta' included in the backstamp. The first colours were Fiesta red, cobalt blue, yellow and green. Others were added.

The middle-priced 'Fiesta' range created interest in the commissioning of a cheaper variation exclusively for sale in the Woolworth stores. This was designed by Rhead's team in 1938, its shapes were lighter and more conventional. It was called 'Harlequin'. 'Riviera' was also a variation on the shapes but supplied with more traditional decal prints.

Taylor, Smith and Taylor of W. Virginia produced 'Lu-ray' in 1938 with modern shapes but pastel glazes, and then 'Vistosa' in brilliant orange, green and yellow to compete with 'Fiesta'.

The advertising material for 'Fiesta' implied that its colours were inspired by the colour of the Mexican Fiesta in California, and certainly Rhead's earlier experiments with glazes had taken place there. What it showed more accurately, though, was the growing interest in the West Coast, where potteries were developing to compete with those in Ohio and New Jersey. Partly based on cheap Mexican labour, potteries which had made building materials began to produce tableware to supply the growing Californian market. Hollywood and its surroundings could offer some lucrative patrons. Two firms particularly expanded at this time. Gladding, McBean and Co. of Los Angeles who introduced 'Fransiscan' ware and Vernon Kilns started

Firing vitrified earthenware at Vernon Kilns in Los Angeles. Illustrated in Pottery Gazette, 1920.

by an Englishman named Paxon using British techniques.

The Pacific Clay Products Co. started making dinnerware in 1932. They had formerly manufactured sewer pipes. Their Art Director was M.J. Lattie and they also developed the use of flat, bright colours. The advantages of spray-glazing with single colours was not lost on the more traditional producers for mass-produced lines. The 'Manhattan' shape which Victor Schreckengost produced in his capacity as designer for the Sebring group of potteries was marketed, not only with the more conventional decals, but in textured colours such as 'Meerschaum' which was a yellow with brown fleck. He also designed for American Limoges their 'Jiffy Ware', a range of informal breakfast ware with modern shapes and bright single colours.

The organization of the American factories and the circumstances of marketing there in the 1930s led them to adopt solutions in ceramic design which Britain would not voluntarily consider in its search for a national style. It was to take the conditions of wartime and direct Government control to bring about such changes.

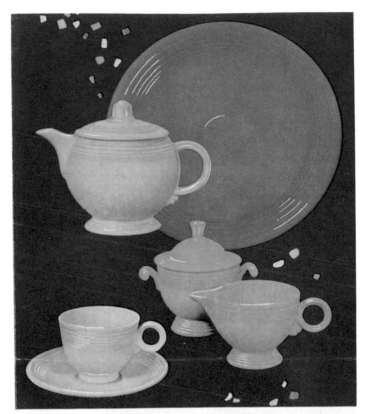

THE NEW

Fiesta

THE HOMER LAUGHLIN CHINA CO., NEWELL, W. VA.

1965 publicity for 'Fiesta' designed by Frederick H. Rhead for Homer Laughlin China in 1936.

UTILITY AND AFTER

IN Britain in the 30s, as has been shown, the experiments in design concentrating wholly on shape were limited. The majority of manufacturers regarded whiteware as simply 'unfinished' and most consumers considered surface decoration on tableware a major necessity in determining its status. It was these attitudes that made the imposition of 'Utility' restrictions after 1942 all the more difficult to accept.

After the outbreak of war in Europe in 1939, the restrictions on production in the pottery industry were contained within the orders issued by the Board of Trade. First, there was the Export of Goods (Prohibition) no. 2 order in September 1939 preventing the export of raw materials needed in production of essential armaments, such as clays and refractory materials; secondly, more relevant to the tableware section of the industry, was the Limita-

tion of Home Supplies (Misc) order, issued to cover the period 1st June to 30th November 1940. This established a quota for manufacturers of tableware for the home market, based on two-thirds of the value of that which had been produced for the same six months of the previous year. However, since this was based on value, and prices were already rising, in terms of volume it meant a reduction of nearly half.

As yet there were no restrictions on design, merely on quantity. The rules were intended to encourage export sales, particularly to the dollar markets, since before the introduction of lease-lend, supplies from America had to be paid for in dollars. It was decided that the pottery industry, though small in scale overall (less than 1 per cent of all manufacturing industry) should be particularly encouraged to export since its record in the past had been good and it relied

so little on imported raw materials.

It was assumed that by putting a quota on home production, the available capacity of these firms could immediately be switched to exports. Many of the smaller firms however, had ceased to be involved with exporting due to pre-war difficulties. The loss of export trade which had taken place after the First World War was significant.

The small potteries which were being coerced into exporting by the restriction of almost 50 per cent on their home sales were mostly producers of low grade china and middle and low grade earthenware. In an industry which was traditionally production, rather than market, oriented, market research was at a very low level. For these firms, knowledge of the American market was virtually non-existent.

Before the War, with the exception of the high grade firms like

Minton, Wedgwood, Doulton etc. who maintained representatives in America, even those firms which did export, traded through merchant organizations, concession houses or agents – a practice which did not lead to direct contact with the consumer. Indeed, to justify their existence, it was in the interests of the import agencies to prevent the producer and consumer, or even retailer, dealing direct. The situation left space for the committed propagandists to step in and supply the lacking information on what it was appropriate to design, and through their construction of that information, to try to influence the direction of British design.

As it was, with this first scheme for restrictions on home trade, the publications representing the views of both the British Pottery Manufacturers Association and the Potters Union protested that exports could not be achieved that quickly, and that the result would be firms reaching their home quota well within the six months period and being unable to increase exports. The factories would go on short-time working and ultimately out of business.

This was in fact what happened, but at the same time the need for supplies of ware at home was highlighted by the bombing of Coventry in November 1940. The day after the worst raids, the Lord Mayor consulted with the Manufacturers Federation and 28 firms contributed 30,000 pieces of basic ware – cups, plates, soup bowls etc. – out of stocks, only to be told that these would come out of their quotas and that, further, they would be liable to pay purchase tax of 16⅔ per cent on their gift. By April 1941 the confusion of demands from the Board of Trade and other Government departments was all too apparent. The editor of *Pottery Gazette* in May 1941 voiced the industry's concern: "*One Government department insists on the limitation of home supplies and the fullest support for export, another wants 10,000 operatives out of the industry for munitions, another has seen fit to restrict supplies of coal and raw materials; and the Government itself has raised the reservation age for military service... We think it is high time a definite statement was made as to what they really do want as regards the potting industry's contribution to the war effort.*"

Whereas the growing intervention of Government in industry had begun in response to the Depression, it had mainly been in relation to staple industries. The pottery industry was not affected and most manufacturers were strong believers in free market forces. But the War was to accelerate direct Government participation and the pottery manufacturer found his entrepreneurial function being undermined as his sources of raw materials, distribution of product, prices, profits, site and location of factory all became subject to licence, registration or some form of Government control. In the case of consumer durables even the appearance of the product was controlable.

It was the apparent failure of the quota scheme and the increasing need to transfer workers out of the industry for War-work which led in April 1941 to the Board of Trade's proposal for the 'Concentration of Industry'. 'Nucleus' firms would be established and licensed. In order to qualify, they had to prove that with concessions on labour and fuel, they could produce and sell to 100 per cent capacity and that 70 per cent of that trade would be overseas. Smaller firms doing less than 70 per cent exports should amalgamate to concentrate production in fewer factories, or close down and be compensated by those firms still in business, thus releasing an estimated 30 per cent of the work-force.

It was the Board of Trade's contention that amalgamated firms would still be able to use their own trade names and keep their own identities and individual lines of production. This enforced 'take-over' policy panicked the Manufacturers Federation as they foresaw a situation where many of the smaller units would never emerge again after the War. In order to oppose the policy, the 'uniqueness' and traditional craft

base of the industry were invoked as reasons why rationalization of this sort should not occur. For example, the editorial of the *Pottery Gazette* read in April 1941: *"Whilst in a total war such as this, a scheme of the nature of Mr. Lyttleton's is no doubt necessary in order to achieve the total economy necessary to victory, it is well nigh impossible of operation in an individualistic industry such as ours. We can think of but very few instances where firms could coalesce with any measure of success."*

And again in May: *"such a position does not apply to an individualistic craft industry such as pottery manufacture where, for the most part, standardization of products is virtually an impossibility."* This last is significant because, despite obvious precedents for the opposite view in Germany and America, it articulates the British manufacturers' perception of the industry. Their ideological standpoint was clearly at odds with modernism – which was understood as an expression of the collective, the machine-made and the standardized.

Despite the protests, the concentration scheme was approved in June 1941. By September, 71 pottery firms had been granted 'Nuclear' status with eight more certain to be accepted, 75 were to close and approximately 60 were transfering to the nuclear firms. Moreover, in the new restriction period of December

1941 to May 1942 limits were placed not just on the amount to be made available to the home market but on the kind.

For the home market, only plain undecorated earthenware and china could be made. There was a limited range of basic pieces that could be produced. The shapes of these had to be registered by the manufacturers and the number of designs could be controlled. They were given Utility numbers and special backstamps. Thus Government legislation was enforcing what had previously been advocated by those concerned with the quality of design, namely,

Advertisement for Spode 'Utility' ware from Pottery Gazette, *1950.*

rationalization of the industry into larger units, concentration on a limited number of shapes, and the elimination of surface decoration apart from a very limited use of banding or single body colour.

In 1942 Oliver Lyttleton was replaced as President of the Board of Trade by Hugh Dalton. It was Dalton who began actively to involve designers in the drawing up of specifications for products to be made under licence and in making recommendations about the implications of restrictions for design. This was placed under the direction of Gordon Russell, who saw the possibility of a new attempt at design reform, related to earlier attempts (such as the Council of Industrial art under Frank Pick) but different in organization, and with the advantage of Government support at a time when Government was intervening to an unprecedented extent in the affairs of industry. Russell himself was mainly involved with furniture, but reflected the mood when he wrote, *"I felt that to raise the whole standard of furniture for the mass of the people was not a bad wartime job... Wartime conditions had given us a unique opportunity to make an advance."*

After the War, this direct involvement of designers was to have further influence through the establishment of the officially backed Council of Industrial Design (Co.I.D.), particu-

larly on those industries where regulation was directing them to markets with which they had lost touch or about which there was some uncertainty. The proposal for such a Council came from a committee set up in 1943 under Cecil Weir. It was significant that it was under the auspices of the Department of Overseas Trade, since initially one of the Council's main functions was to improve British exports. In 1945 after the end of the War and the General Election, Sir Stafford Cripps became President of the Board of Trade and responsible for the Council, and while many contributed to its policies, Stafford Cripps' own attitudes to design and his strongly held ideals encouraged it in certain directions.

His idea of the post-war world was a British, Christian, Socialist state. His early concerns with form and function in design were based on reading writers such as Ruskin and on his interest in traditional craftsmanship. These were fostered by his association with Sir Lawrence Weaver, who whilst being an architect and a critic, had become involved with a plan after the First World War, influenced by people such as C.R. Ashbee, to resettle depopulated areas of the country with ex-soldiers to form self-sufficient communities based on agriculture and craft production. When Stafford Cripps first got to know Weaver he was setting up the Ashstead Potters Ltd in Surrey with such ex-servicemen.

They produced ornamental ware initially but soon expanded to tea sets and tableware. The pottery could not survive the Depression and closed in 1936, but up until then Stafford Cripps was its chairman. This gave him some knowledge of ceramics and in 1931 he had chaired a meeting of the D.I.A. at which Joseph Burton of Pilkingtons had given a lecture on 'Experiment and Tradition in the Potteries'. This background meant that Stafford Cripps had much in common with Gordon Russell and other D.I.A. members who formed the basis of the new Council. Those who most admired and supported International Style modernism were not so directly involved, although Pevsner had been appointed Design Consultant and buyer in textiles, pottery and glass for Gordon Russell's firm, while Herbert Read was a founder member of the Design Research Unit.

Critics of design recognized that their opportunities for intervention and the achievement of aesthetic goals were intimately related to the development of the post-war socialist Government and its social and economic policies. Read realized that the production of new forms was not sufficient to change the consumers' demands in design, nor was a straightforward attempt to 'educate' them – an attitude already being adopted by the newly formed Co.I.D. While the structure and values in society remained the same, so, in Read's opinion, would the demands made by the consumers of their domestic products. In relation to the machine-aesthetic he wrote: *"the impersonal values which we find characteristic of machine-art would stand little chance of firm establishment did they not correspond with a wider shift in values in society. In every sphere of human activity, even in religion, the values of individualism are challenged... The new aesthetics finds an echo in the new politics, the politics of collectivism"*.

A less radical view was taken by Pevsner who saw intervention and control as an acceptable means of improving a society which had not yet reached the position outlined by Read. When asked in a questionnaire by the editors of *Pottery and Glass* whether the compulsory limitations of Utility pottery would prove beneficial or deleterious to future design, he answered that he believed that the enforced concentration on shape would be a great asset. Other replies to the same questionnaire focussed on the question of craftsmanship. John Adams of Poole's response was typical when he said that as far as craftsmanship was concerned the wartime regulations had been disastrous. As far as he could see, the making of Utility of ordinary standards could

not possibly benefit future design.

The question about the effect of Utility controls on design by *Pottery and Glass* in 1944 was posed with the expectation that production in all sections of the industry would resume fairly quickly after the end of the War in Europe. But in the event the deconcentration of industry and the lifting of restrictions were subject to the overall economic planning of the post-war Gorvernment.

Already in the General Election speeches of 1945 and increasingly in subsequent by-elections, many Conservatives were campaigning for controls to be removed. The Labour Government, whose programme included nationalization of large sections of industry and the provision of increased health and welfare services, saw control as a social instrument. They knew that if controls were removed excess demand and limited supply would force up prices and, apart from the inflationary effect this would have, it would mean that many goods would still be beyond the means of the poorer sections of the community. Prior to 1945, however, detailed discussion of industrial policy had been lacking, apart from an overall commitment to full employment. Even before the election, calls were coming for some definite statements on some industries including pottery.

An article in *The Economist* in April 1945 entitled 'A Pottery Plan' asked what the future of the pottery industry was to be. Policy during the War had had a profound effect on its manpower, equipment and methods. Was its re-conversion to be left exclusively to the same 'automatic market forces' which had ruled it in the past? Was transition to be nothing more than a return to the conditions of 1939? The article argued that it was far more difficult to modernize an old industry than to build a modern one from scratch. The reconstruction problem of that industry was every bit as important as other sectors of the British economy more in the public eye. It concluded, *"This is not an industry which is likely to reach a satisfactory state by being left alone. There is a general case for intervention by public authority."*

A working party was set up by Stafford Cripps to look at the industry in 1945, but Cripps pre-empted its findings by assuring the manufacturers in advance that there was no intention to nationalize the industry. He was easily convinced by their arguments about 'craftsmanship' and 'individualism', and he had his own doubts about nationalism and workers'-control. The results of the working party were a compromise – no nationalization but no lifting of controls. The manufacturers were disappointed as they wanted a return to a free market as soon as possible. The Union was also disappointed, as they had published their own report calling for short term advance under strict public controls and, in the long term nationalization. The working party wanted modernization and rationalization brought about through a combination of controls and coercion.

One of the biggest obstacles to the operation of continuous production line working was the haphazard way most of the small factories had grown up during the 19th century. It was a measure of the strength of Wedgwood as a company that in the pre-war years when few firms where risking any capital they had decided to build a new factory at Barlaston, south of the city of Stoke. It meant that they could take advantage of the developing technology in kilns and firing techniques and produce to capacity as required both during and after the War. Other factories were less fortunate, they wasted a lot of time moving ware from one process to another, often up and down levels. With the post-war situation of labour shortages and the need for increased production, it was argued that factories should be re-planned to use more mechanical processes and the more efficient tunnel kilns. These changes to maximize efficiency would necessitate a continued limitation on the number of designs and would force their production in longer runs.

So, in order to keep production concentrated on exports, money was made available for new plant, restrictions on the home market were kept and the Co.I.D. was going to play a role in encouraging suitable designs.

As it happened, Germany and Japan, Britain's largest rivals for the American market, had not yet had a chance to revive their industry, so (briefly) it was a sellers' market and the Manufacturers Federation felt that their traditional ad hoc approach to market research was good enough. This belief was enhanced by their strong suspicion of the Co.I.D. which, as an agent of the Board of Trade, was associated with central Government.

The 'Britain Can Make It' exhibition acted as a focus for resentment and also the expression of theoretical positions on ceramic design. The exhibition was intended to show that British industry had survived the War and could still compete in world markets. Most of the goods on show were still not available to the public and it was quickly nicknamed the 'British can't have it' exhibition. It was a selective show with the Council doing the selecting, and what it represented was therefore a concensus view of 'good design' as reached by members of the Council. Stafford Cripps in his preface to the written survey of design which accompanied it said that it was these 'new pioneer' goods which

would help maintain exports. It was this that the potters argued with. They claimed that what in fact were good exports were not in the exhibition. As it happened few of the ceramics shown were new. The kitchen in the furnished rooms section was entirely supplied with Cornish Kitchenware and Denby stoneware from Joseph Bourne Ltd, designed in the 1920s. The ceramics in other sections consisted of Keith Murray's pre-war beer mugs, designs by Ravilious, and other Wedgwood 18th century creamware. Moorcroft's 'Powder-blue' ware was also included – in other words, all the things that had been validated as good design well before the War. It was seen by the factories as showing not what the Americans wanted to buy, but propaganda for the Council's own theories on design. A book written for Penguin with the aid of the Council had all the same examples in it.

While the Council drew on the pre-war writings of Read and Pevsner, the pottery trade press began to retaliate by finding its own sources of authority. In an article on the 'Britain Can Make It' exhibition, *Pottery and Glass* quotes from W.B. Honey's book *The Art of the Potter*, which criticized Read's views and claimed that the modern style was just a period style like any other. The chapter that included this passage was in fact a paper that Honey had delivered

to the Manufacturers Federation in 1945 and they saw it as a justification of their ideas.

Honey believed that not only was modernism a period phenomenon but that it was a regional one. 'Good' taste in pottery was invariably conditioned by place as well as time. Aesthetic values changed with race, climate, tradition and environment. He put great value on tradition by which he meant *"a national way of doing things – such a tradition in pottery refers above all to the national preference for certain shapes and proportions."* He then compared tradition to a language, which needed a degree of familiarity and common understanding to be comprehended. 'Modernism' he suggested was an invented language, synthetic and not natural. To justify English tradition on the grounds that it was 'natural' (while the alternatives were historically and culturally determined) was to deny it its own dependence on a specific time and place. But he then went on to use a good many of the same old examples of pottery that had been cited so often before, arguing that it was indeed their traditional Englishness which made them good designs for subsequent generations.

Honey organized an exhibition at the Victoria and Albert Museum, where he was a keeper, which gained the wholesale approval of the trade press who declared that it provided

"a source of informed and unprejudiced aesthetic pleasure for the public upon whose patronage the designer depends." The implication was that his selection was unprejudiced whereas the Council's was not. These arguments around one exhibition may seem disproportionately heated, but they were one facet of a much more important issue, the question of design for the American market, and the general distrust of enforced modernization.

To eliminate the 'dollar gap' created by the cancellation of lease-lend in 1945, Britain would have to increase its volume of exports by 75 per cent above pre-war levels. It was this need for dollars which was putting the pottery industry under such pressure.

Manufacturers were being asked to produce for the Americans without knowing very much about them and against the background of some suspicion of G.I.s which had grown up during the War. The interest in American culture, particularly music and films, was a constant topic in the popular press, which represented the Americans as a threat to British cultural values, while also being fascinated by them. Initially there did not seem to be a problem. Because European ceramics had been in scarce supply and America's own production had mainly been re-directed to supplying the forces, there was a backlog of consumer demand, so Britain could sell almost any ware that was produced. But by 1949, even though the de-valuation of the pound made British goods cheaper to buy, it was becoming apparent that the kinds of design being offered were no longer in demand once the backlog was satisfied.

In the trade press, reports noted that patterns of the old conventional designs were no longer accepted in the states, and J. Taylor of the North American buying office in Hanley explained that the poor consumer demand was brought about by a great interest in modernism, both in shapes and decorations, in America. This, he said, might present British producers with problems but he had no doubt some would be able to supply them despite the lack of market for 'seconds'. The difficulty there was that it was thought that the home market, to whom a limited amount of sub-standard decorated ware could usually be sold, would never accept such modernist designs whatever the shortages, and that therefore all 'seconds' would be wasted.

The more fully automated American industry which had been developing its design in the 30s, was now creating a demand for a different type of goods. Helen Styles writing in 1941 could say: *"Because of the present disturbances in Europe there would seem to be a bright future for the bet-ter grades of china made in the US for use in our homes today... Perhaps the time will come when we will depend less and less on foreign potteries for our fine tableware."*

What was emphasized continually was not only the greater degree of mechanization in the American industry, which was held up as a model to British firms, but the difference in lifestyle on the part of the consumer. This was represented in many articles and references as being more 'outdoor', 'casual' and 'informal' than the British lifestyle. Michael Farr of the Co.I.D. attempted an analysis in an article in *Design* magazine in December 1952 about modern design in American ceramics:

"Its immediate origin can be found in the designs developed by Californian potters, mainly since the war, although elements in the style can be attributed to Swedish and Danish work in the 1930s. After several years of being rather precious and obscure the style has made a progressive conquest of the markets in the US from west to east coast. A large percentage of American manufacturers have since taken it up because it accords convincingly with the current American practice of 'informal living' a practice which implies that meals, preferably of the buffet type can be taken in the garden, off the kitchen table or on the living room floor."

He goes on to say that he questions whether this social phenomenon has been expressed accurately in aesthetic terms, it is the Americans' idea of a modern style, but not necessarily his ideal.

In opposition to Farr's view, those manufactureres who still had old-fashioned facilities argued strongly that what in fact Americans did want from Britain was the representation of tradition and Englishness. The ordering of a range of ware from Wedgwood to celebrate the completion of the Colonial Williamsburg project was cited as an example of America preferring 18th century reproductions. The restoration of Colonial Williamsburg was proposed by John D. Rockefeller in 1927. It had, in fact, in the 20s contributed to the interest in early American colonial styles, but by the 1950s this interest was much less marked. The 'Williamsburg Husk' pattern supplied by Wedgwood was not an exact replica of an early style supplied to the colonists, but a lithographed transfer on the 'Queens shape' of a hand-painted pattern originally made for Catherine the Great. It looked more '18th century' than the originals. This reversion to rather ornate lithographed designs, if anything overstating the 'traditional' was still in progress at the time of the Festival of Britain.

Much has been written about the Festival and the varying claims made for its influence on British design in the 50s depend on the attitudes of the writer. It had first been suggested during the War that a major international exhibition should be held. Stafford Cripps had called for a report which concluded that despite the difficulties it should be held in 1951, partly as a centenary celebration of the 1851 exhibition, partly to mark the recovery after the War. But by 1951 only a national exhibition was being proposed and there was still opposition and a call for its delay. The Korean War led to a pressure to re-arm.

Many manufacturers responded with hostility or indifference to the Festival, and, in contrast with the claims of the Co.I.D., co-operation was not that widespread. In addition to the general complaints of expense and lack of adequate space on the South Bank site in London, deferment was called for on another count. It was going to be another selective exhibition. The *Pottery Gazette* wrote:

"The Council of Industrial Design has seen fit to debar from the Festival any design that so much as hints of tradition... Better not to have it at all if the traditional craftsmanship of past centuries... (is missing) than to mislead overseas visitors into thinking that our industrial designers have gone crazy."

The firms who did provide goods when asked by the Council were mostly those supplying the top end of the market – Wedgwood, Doulton, Moorcroft, Susie Cooper etc. But even these felt they would not be fully represented and made additional arrangements. Wedgwood, Worcester and Doulton all held shows of their own in London and a large exhibition (non-selective) was held at Stoke for the less well-known firms.

One of the features of the Festival was the activities of the Festival Pattern Group. This was established to try to interest designers in the patterns created by crystal structures as seen through the new high-powered microscopes. They hoped that the abstract and geometric patterns thus observed would provide an alternative source for design to the inevitable natural history, one which was appropriate to the modern world with its connotations of 'scientific truth', 'progress' and technological skill. One reason the crystal patterns were viewed with some scepticism was that the scientific 'hardness' of the designs equated them with masculinity, whereas tableware was perceived to be mainly feminine in its appeal. As it happened some experiments were made and some firms did agree to make ware decorated with designs from this source, namely Wedgwood, E. Brain & Co. and R.H. & S.L. Plant Ltd, but the designs were supplied by students studying at the

Royal College under Professor R.W. Baker. The crystal pattern designs were used for tableware in the Regatta restaurant on the South Bank.

Divergence of opinion about the direction design should take was in fact already becoming more noticeable in 1951-2, and the staunch pro-tradition stand taken by the trade papers no longer accurately represented all manufacturers. Some of those concerned with high grade earthenware were becoming aware that to retain their export markets they would have to produce more contemporary designs. The rest were encouraged by the Labour Party's small majority in the election of 1950, raising hopes that the Government would be forced to reduce controls and open up the home market to decorated pottery. The firm conviction that British consumers would have no truck with American-inspired modern designs led producers to believe that if they could hang on long enough they would be able to sell all the traditional and conventional ware they could produce.

The future of the Utility scheme was debated and Labour, who wanted to see it continued as part of a planned economy and a means of re-distributing goods and wealth, lost the vote. As a result, the restrictions on decorated pottery were lifted in July 1952, almost exactly ten years since they were first imposed.

One of the first things that became apparent was that although there was an increase in consumer spending while people re-stocked, it was not as vast as many had hoped. Britain, too, was changing its attitudes to living and eating habits. It was at the extreme ends of the market that the demand for traditional designs was highest. The consumers of high-priced china still wanted tangible evidence of skill and time spent in the elaboration of the pieces, while to those buying cheap earthenware and china, price was a greater consideration and any lithographed flower-sprays were acceptable. It was amongst the consumers of the middle ranges of china and higher priced earthenware that, somewhat to their surprise, manufacturers found an increase in demand for designs closer to those being advocated for America.

Firms such as Carter, Stabler and Adams and W.R. Midwinter, both producers of better quality earthenware, made conscious decisions to

'Festival' design plates by Jessie Tait in the Stylecraft range by Midwinter, c.1953-4. Although designed after the Festival of Britain they have affinities with the Festival Pattern Group's crystalography.

Casserole in the original Midwinter Stylecraft shape. The pattern is 'Primavera' by Jessie Tait, c.1952.

Cup, saucer and plate showing the use of screen-printed on-glaze transfers as discussed on page 84. Produced by Wade, Heath & Co. Ltd, c.1957.

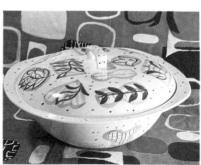

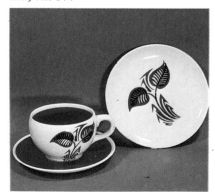

develop their design policy along these lines. One shape innovation that had been much argued about for the American market was the 'coupe' shaped flatware. This rimless plate had been produced before but generally for serving rather than as an eating plate. It was rarely produced in Britain until the need to concede to American eating habits was recognized. Several firms had started making them for export but had believed that it would never prove popular

with the British because, as cliché had it, there was 'no place to put the mustard'.

One of the examples of American design which Michael Farr used in his article in *Design* magazine to illustrate America's own production to British designers, was Russel Wright's 'American Modern' with its fluid shapes and single colour glazes, produced as a range of separate items which could be combined as needed for meals. Although 'American Mod-

ern' was designed in the 30s, Wright was still producing lines based on these concepts, for example 'White Clover' for Harker Pottery Co. Greater flexibility was needed for the building up of collections of tableware in the home. Buyers, particularly those moving into new homes and with limited means, liked the idea of starting with a small basic set and then adding whatever individual pieces suited their needs. The old practice of buying large elaborate sets of specialized dinner or tea ware was disappearing.

Another designer whose work was featured by Farr was Eva Zeisel. Zeisel was born in Budapest in 1906 and, after studying at the Academy of Fine Arts, became an apprentice to learn ceramic techniques. She worked in a variety of countries in Europe becoming familiar with ideas of design in Vienna, Germany, France and Russia before emigrating to the States. Her work, particularly for the Schramberg pottery in the Black Forest, showed her understanding of modernist principles in its simplified geometric shapes and concentration of form. In 1938 she and her husband came to New York. She designed giftware initially, much of it similar in design to her work in Europe. In 1939

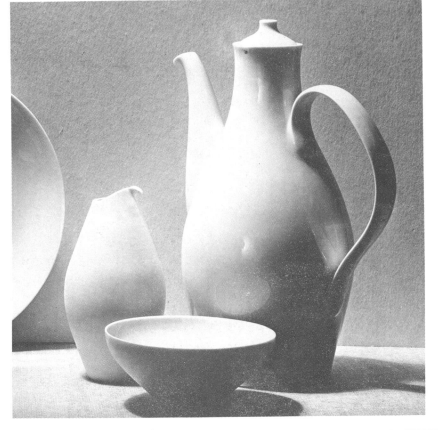

Museum dinner service designed by Eva Zeisel for Castleton China, c.1942-45.

she began teaching at the Pratt Institute. She changed the basis of the teaching there from a concern with hand craft to a concentration on design for industrial production. One feature which was introduced was a period of 'placement', giving the students an opportunity to work in industry.

Some of her students went to work with Frederick H. Rhead in his research studio at Homer Laughlin. She and the students were commissioned to design a set for Sears Roebuck, named 'Stratoware'. The downward-swept streamlined handles on this and her prototype for kitchenware make an interesting comparison with later British attempts at modern design in the 50s.

The most important of her commissions was to design a dinner service for the Castleton China Co. of Pennsylvania who contacted her through the Museum of Modern Art. This service in fine quality china, rather than earthenware, reflects back to her knowledge of German design of the 30s in Europe, though there is a certain exaggeration of form more reminiscent of Vienna. It was not until 1946 that 'Museum' was put on the market.

'Town and Country', which she produced as an earthenware service for the Red Wing Pottery of Minnesota, was a result of the growing demand for modern informal dinner-

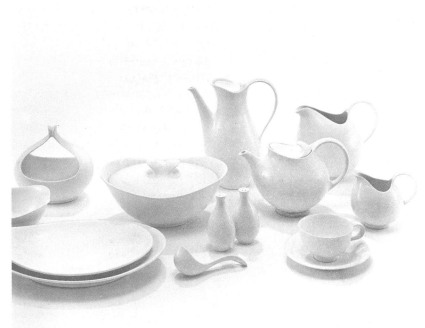

Dinnerware designed by Eva Zeisel – Tomorrow's Classic' for the Hall China Co., c.1952.

ware. Like the pre-war modern designs it relied on colour and the 'mix and match' approach. The shapes are very fluid and biomorphic. The origins of these shapes in 50s design are much debated but such amoeboid forms arise in pre-war European design as a reaction to the severity of geometric modernism. Zeisel like others realized that these biomorphic shapes were highly suit-

Sketches drawn to illustrate the development of Stylecraft 'Fashion' shape by Roy Midwinter.

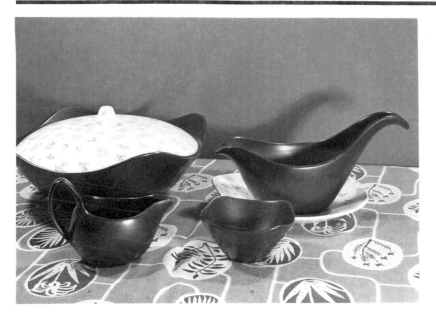

'Monaco' pattern on Stylecraft 'Fashion' shape. The shape was designed by Roy Midwinter, 1954.

Porcelain cup and saucer in 'Mon Amie' pattern introudced c.1956 by Rorstrand of Sweden and only recently taken out of production.

Below: Coffee pot, cup and saucer in 'Polka dot' pattern on Ringwood ware by Wood & Sons Ltd. The 'streamlined' appearance harks back to some pre-war shapes although it was designed c.1955.

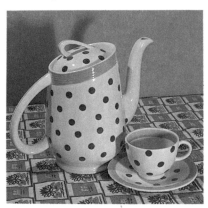

able to ceramics and were indicative of the soft and flowing nature of clay itself.

Certainly many of Zeisel's forms owe obvious debts to her knowledge of pre-war European work. A dish by her which appeared in Farr's *Design* magazine article was commented on by Stig Lindberg, designer for Gustavsberg, who suggested that it was so close to one of his designs that it was too close. 'Tomorrow's Classic' design for Hallcraft also has much in common with contemporary Swedish design. Swedish firms, like Gustavsberg, had moved in the late 1930s to using more organic plastic forms as a reaction to the austerity of modern purism. Wilhelm Kåge's 'Set of soft shapes' of 1937 indicates this shift clearly in Sweden.

These soft, more plastic shapes are interesting in relation to the development in England of Roy Midwinter's 'Stylecraft' range. The first version, which was designed as an export shape in response to the 'dollar drive', was fairly tentative in approach. The flatware was described as 'semi-coupe' – a large well with a narrow, shaped rim. The jugs and tea-pot had a slightly squared profile but with a simplification which demonstrated their concern with functional considerations and mass-production. The second version, the Stylecraft 'Fashion' shape, showed a move towards a

much closer concern with the organic forms of American ware. It was designed during 1954 and put on the market in 1955. The plastic quality of the shapes and the fully coupe flatware indicated a conscious break with conventional designs and a desire to express the firm's commitment to modern design.

In the early 1950s Roy Midwinter visited the United States in order to gain first hand information about what was being produced. He found that the East Liverpool area was declining, and many of the 50 or more pre-war factories were closing or amalgamating into a few very big units. It was the west coast, which had developed its tableware production in the 30s, which was designing the more interesting wares. Midwinter saw the work of Russel Wright, Raymond Loewy and Eva Zeisel. On his return he began to develop Stylecraft specifically to emulate American models. In 1952, just before the lifting of the home restrictions, work on the first Stylecraft shape was under way.

By the time Stylecraft was launched the home market was available and, while the American concentration on single colours was maintained in the holloware, decorations were designed to co-ordinate with them on the flatware. Besides Jessie Tait who was the designer of many of the patterns, Midwinter

obtained designs from other young designers, notably Hugh Casson and Terence Conran. With support in distribution from the Independent Stores Association both ranges initially sold well.

Competition from other produc-

ers of contemporary design, as this 50s modernism was called, was growing, though not all solutions owed their origins quite so distinctly to America. The emphasis in much of the post-war literature was the changing nature of the home and the need for domestic tableware to be seen as part of a wider context. As a result, designs emerged that implied they were a component in a larger unified system. The visual and pictorial

Plate from the Homemaker set c.1955 by Ridgway Potteries Ltd.

Below: A series of asymmetric dishes by Carlton Ware Ltd, 1959, including an eggcup-cum-plate in the 'Windswept' pattern.

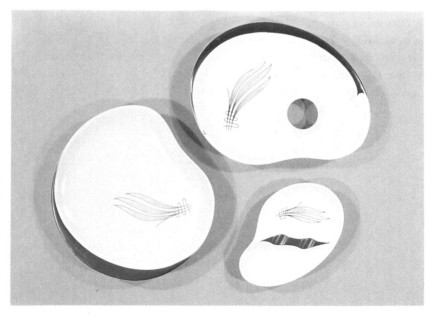

images referred to products, materials and social practices outside those usually associated with ceramics. For example there were a large number of designs referring to textiles e.g. 'Gingham', 'Plaid', 'Tweed' and 'Homeweave'. There was also the somewhat ironic Ridgways 'Homemaker' set depicting contemporary furniture, the work of supporters of the Co.I.D.

The period between 1953 and 1956 saw the production of some of the more extreme examples of contemporary post-war design in the ceramics industry. These were aimed at a target market of the middle income bracket and under-40 age group – the people whose lifestyle had perhaps been changed the most in the years after the War. More women in this group were continuing in jobs and it was to these people that the labour-saving aspects of goods were sold. Convenience foods and the practice of eating out or 'taking-away' was becoming more common and as a result mealtimes became less formal. The family structure and relationships that mealtimes had reinforced in the 19th century were slipping, young members becoming more independent and less respectful of authority.

The great strides in the development of plastics during the War gave rise to real fears on the part of the pottery industry that plastic tableware would become a major rival in this informal sector. Many new ranges of plastics were designed, including one by Roy Midwinter for Melmex, very similar to the 'Fashion' version of Stylecraft. Consumer resistance was, however, too strong to overcome and plastics have never taken over the market to the extent that was then feared.

New techniques were also being introduced within the industry. For Stylecraft, Jessie Tait had designed many hand-painted patterns, while the pictorial ones were applied by lithographs. But a new technique for producing transfers was being developed by Johnson Matthey in Britain, which was screen-printing or serigraphy. This had been experimented with in America and elsewhere before the War but not made marketable until after it. The technique took time to introduce as it involved new methods of application. Also screen printing at the time could only produce thick, flat-colour designs, and not the subtle tones of lithos. A growing interest in bright colours and the modern trend for stylized and flattened motifs, however, made the process more appropriate. As informal pieces were now expected to have a shorter working life than in the past, the fact that these on-glaze transfers did not wear so well, did not matter.

One interesting result of this technique of super-imposing layers of flat colour was the reference in some designs to the nature of the process itself, with quite deliberate 'off-registering' included in the pattern. This 'layering' is apparent in a lot of examples of contemporary textiles where screen-printing was used before it was in ceramics. It can be seen in the super-imposing of motifs over a frame rather than within it. These characteristics of textiles were even adopted for hand-painted designs, such as Jessie Tait's 'Primavera'.

The single colour sprayed-on glazes American mass-production techniques encouraged, combined with the pictorial designs on plates etc., accorded with a tendency current in interior design – to treat wall surfaces as large, flat areas of colour contrasted with bright patterns. The flexible 'mix and match' sets were easier and cheaper to produce. Manufacturers of middle priced earthenware who, during the 50s, responded to Government pressure to gear themselves up for a higher degree of mass-production could decorate them by automatic spraying and make up the 'harlequin' sets, as they were known in the packing shop.

Some of the developments which had taken place in Europe and America had been introduced in Britain, often against the will of the industry itself, and as a result of Government intervention.

CHANGING LIFESTYLES

THE change of policy towards contemporary design by British middle-market manufacturers was made in an attempt to strengthen their hold on a declining market. The volume of British ware being imported by the USA was steadily going down, whereas American imports from Federal Germany and Japan were increasing. In 1955 Japan's re-constructed industry overtook Britain's in the value of its exports of pottery to the United States, and as its pieces were cheaper this must have represented a considerable increase in volume. The decade from 1945 to 1955 saw a transformation in the Japanese industry due to extensive mechanization and the concentration of industry into larger scale units.

In 1949, Japan had 4,428 china producing works employing some 60,000 people, 80 per cent of all the works employed fewer than 20 people. Numbers in 1949 were roughly the same as for pre-war employment but they were only producing half the pre-war output. This was attributed to antiquated machinery, a lack of skilled labour and the loss of overseas markets. Manchuria, Kwantung and China were now closed to Japanese exports.

A rationalization and modernization programme was carried out in the industry considerably helped by Government subsidies and massive aid from the banks. The return of the Conservative Government in Britain in 1951 brought an end not only to controls but to most of the aid for reconstruction, with the result that nearly all the growth in world markets for domestic pottery was being taken up by subsidized industries like the Japanese. With the loss of pre-war markets Japan was forced to concentrate increasingly on the USA and Canada, in direct competition with Britain. The American occupation after the War, it could be argued, gave them the opportunity of studying the market at first hand.

The peak period in the production of domestic tableware in Britain was 1953, a year after the home market restrictions were lifted. By 1956 there was a further credit squeeze and consequently a sharp decline in trade, with many small firms going out of business.

In 1957, 13 manufacturing companies had gone, including some very well known names and also some small companies which had started after the War to cash in on the expected boom. Branksome China was one such which produced some very interesting work in fine earthenware between 1945 and 1956.

The failure of the older firms was attributed to their inability (practical or financial) to modernize, or to a deliberate policy of not modernizing, their factories. In many cases modern firing equipment had been installed but less attention had been paid to making machines and conveyors etc.

A report produced by A.G. Hayek, consultant engineer to the Potteries, in 1950 stated that the majority of buildings used by the American industry were not more than 20 years old and none more than 30. Considerable thought had been given to the through-flow of ware, but the most significant technological development could be seen in the firing methods. Intermittent kilns were obsolete except for a few special

Advertisement for Noritake Ivory China from the cover of the Christmas issue of The Crockery & Glass Journal, *1927.*

processes; tunnel kilns were in use in all the factories.

Tunnel kilns had been developed in the latter part of the 19th century but had met with many problems and it was not until 1910 that they became a commercial proposition. Even at that time the only tunnel kilns being built were very large and so only suitable for factories which turned out ware on a very big scale.

During the period 1908 to 1910 Conrad Dressler was working on tunnel kilns in England. He developed one in which the combustion gasses were confined within a flue on each side of the kiln, in order to protect the ware from the direct impact of the flames. In 1926 the Dressler tunnel kiln organization placed the multi-burner type of kiln on the market. This gave a more even distribution of heat and could utilize oil, gas or coal. In the early days of experiments, it was believed that very large units were most economical. In particular, it was considered that small kilns did not compare favourably from the standpoint of fuel consumption. Therefore in Britain, those tunnel kilns which were introduced were mainly used in brick and tile-making works where a standardized production could supply a continuous flow of ware through the tunnel kiln.

The intermittent coal-fired 'Bottle' ovens in British firms acted as the regulators in the cycle of production in the factory. The packing, firing, cooling and unpacking determined the speed of production throughout the whole works and everything was dependent on it. The introduction of the continuous firing kilns changed not just the efficiency of firing but all the work schedules.

At Barlaston, Wedgwood had chosen to install the Swiss designed Brown-Boverie electric fired kiln. By 1951-52 throughout the whole ceramics industry (including sanitary ware, electrical ware and tiles) 303 tunnel kilns were in use and of the approximately 2,000 coal-fired intermittent kilns that had been in use in 1938, only 650 were left. By 1965 there were 11.

Betwen 1956 and 1963 there were a series of closures, take-overs and mergers which resulted in a reduction in the number of firms producing domestic ware from 130 to 94, with a large proportion of the output concentrated in a few big firms.

These upheavals caused fluctuations in the output and although it steadily rose between then and 1972 it never reached as high a point as it had in 1953. While these changes were taking place there were few really new initiatives in design. The most notable perhaps were in those larger firms whose size and reputation allowed them to defer takeover as long as possible. In 1958 Copeland & Sons (Spode) had produced no new shapes since the War. They had successfully based their exports on a return to 18th century designs but at the end of the decade it became obvious that they needed a contemporary shape for both export and home markets. An exhibition was organized in 1958 at the Tea-Centre in London called 'A room of our own' and was to show the work of students of the Royal College of Art. Copeland agreed to produce the range of tableware to be shown if they approved the students' designs. Neal French and David White were the students who

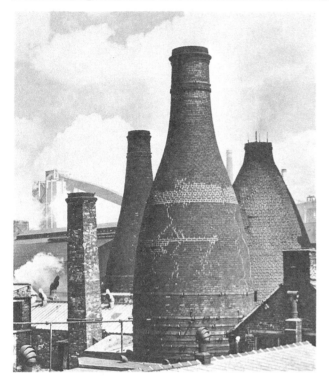

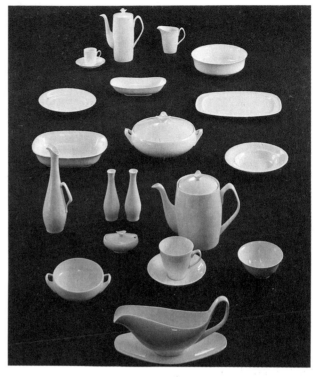

Wedgwood's Etruria factory showing the typical form of the brick-built intermittent bottle kilns.

'Apollo' the white version of the 'Royal College' shape.

designed the shapes, dividing the work between them – French mainly designing the dinner ware and White the tea ware, with obvious overlaps and collaboration. It was first marketed by Copeland as 'Royal College Shape' but after winning a Design Council Award in 1960 it was re-titled 'Apollo', the name of its undecorated form. David White went on to work in teaching and as a studio potter in porcelain. Neal French left the

Royal College in 1958 and went to work at the Worcester Royal Porcelain Co. where he worked on their 'Severn' shape, marking the re-introduction of hard-paste porcelain tableware in Britain. Both these designs emphasize the fine quality of the materials, and in their refinement and concentration on shape for the top end of the market they come closer to Continental porcelain forms – particularly in the case of the 'Apollo'.

After the initial success of Stylecraft on the home market, Midwinter introduced new shapes, and in the early 60s took onto their design team

David Queensberry, who had already done some work for Crown Stafford. In collaboration he produced the 'Fine' shape which, with one of its decorations – 'Sienna' – sold very well. But while the firm concentrated on design their production was disorganized and often unable to keep up with demand.

The experience of Midwinter highlights two features of the early 60s. First, the recognition that among the younger generation purchasing

power was increasing, that work by younger designers was needed to attract this group and that designers could head their own firms. Second, that the traditional family management system within the industry was breaking down and that professional management teams, aware of the practices of market research, scientific accounting and design management, were necessary as amalgamated firms became larger and many were taken over by holding companies with no specific interest in pottery as such.

Consumer spending on pottery was increasing but nowhere near as fast as the growth of consumer spending as a whole. It was again a declining priority within the household budget. Some positive marketing was needed to achieve growth.

In many of the take-over bids the eventual companies contained firms which had formerly concentrated on different sections of the market. This extended the range of each group but necessitated management of the design policy across the whole spectrum. Design became increasingly recognized as a necessary factor in the organization of industry. Ceramics would no longer sell themselves simply on the grounds of being necessary basic domestic objects. To keep up demand they had to be more clearly identified in the public mind as 'fashion' objects.

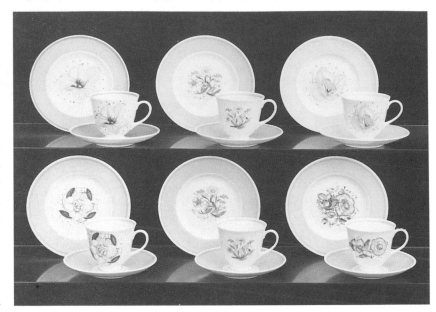

Selection of bone china teaware designed by Susie Cooper for Wedgwood c.1960.

The recognition that different groups of consumers could be singled out by their different lifestyles, and that their aspirations could be reinforced by advertising, was in some ways a vindication of the diversity of demand which had been deduced from empirical evidence earlier in the century. The fact that young people were seen as separate and identifiable groups led to the acceptance of the fact that society contained a plurality of lifestyles, and thus of tastes. The idea that there was one dominant standard to which all should subscribe – and which they should be educated to accept if they did not – was being eroded. Supposedly altruistic 'education' about design was being replaced by American-style advertising. Education for the good of the soul was being replaced by education for the good of trade.

Even the Design Council (as the Council of Industrial Design had become) talked less and less about function and more about style. But at this point they were beginning to turn their main attention to engineering design and corporate identity projects, rather than to the old consumer durables like ceramics and furniture.

The overt recognition of different sectors of the market and the need for more specialized types of design encouraged the use of younger, often

ex-Royal College students and also designers from other sectors of industry. Pat Chewter who was then Assistant Art Director of Thos. C. Wild Ltd described in 1965 the situation of a few years earlier. *"I saw clearly the power of fashion, the importance of Vance Packard and realized that Americanism was more a stage of development than a national characteristic.. Fashion as planned economics was suddenly with us."*

The names of designers who were beginning to make an impact became selling points in themselves. Mary Quant designed mugs for Staffordshire Potteries and Barbara Brown, better known for her textiles, designed surface patterns. The interest generated in the so-called 'swinging London' of Carnaby Street and Chelsea boosted British products.

These fashion-oriented wares which consumers were encouraged to regard as having a fairly quick turnover, were concentrated for the most part in earthenware production. From the mid-60s onwards the plurality of styles was becoming increasingly evident. Besides the popular imagery of graphic art, widely used, there was a growing nostalgia for Victorian design. This was partly due to renewed interest in Morris

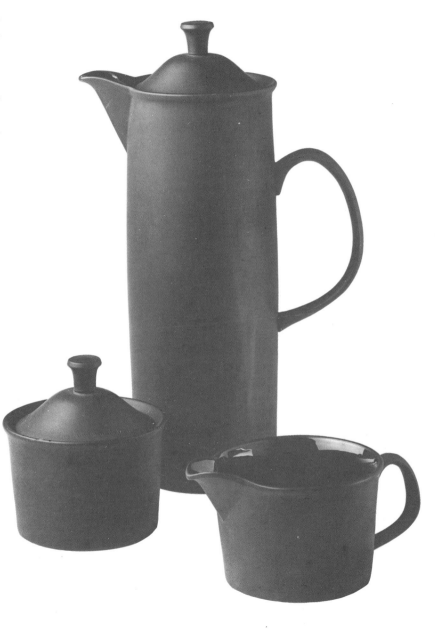

Black basalt cylindrical coffee pot designed by Robert Minkin for Wedgwood, 1963.

and the Arts and Crafts designers who, with their emphasis on Utopian socialism and craft values, seemed to offer an alternative to increased industrialism and the threat of science. Publication of articles on Victorian design and a number of major exhibitions all helped to foster this desire to get away from the material. Anti-materialism, combined with a new fashion for deliberately created 'lifestyles' developed further and generated a fascination with the aestheticism of English and French Art Nouveau. The textiles of Laura Ashley and Sanderson's revivals of Morris designs were combined with Art Nouveau posters and ostrich feathers. In tableware the same trend gave a renewed vigour to the production of blue and white under-glaze prints and other forms seen as typifying the 19th century. This was perhaps ironic as these designs were essentially products of Victorian industrialism. Numerous lithographed versions of the original engraved prints were made, much poorer in quality of detail but very successful nonetheless. Some smaller firms which had continued to produce ware of this kind found that it was now being bought by a new market.

A cycle of revived period styles ensued, marked particularly by the increase in sales of ceramics in junk shops and antique markets as the work of 20th century names such as Clarice Cliff and the work of firms like Shelley became collectors' items. Their attractions were all those qualities which modernism expressly denied – colour, pattern, specific historical association, sentiment, impractical shapes etc. They were rich in meaning and initially low in price. Excercising one's knowledge of historical styles and ability at conscious pastiche became, for the purchasers of this ware, a means of expression in itself. Objects which were available to a wider range of the public than were expensive antiques gained new significance when included in people's modern interiors.

When, in the 20s, Harry Trethowan had chosen to market the contents of the China and Glass department by displaying them on pieces of Heal's furniture, this was commented on as unusual. The selling of china and glass had always been seen in Britain as a specialist activity carried on primarily through shops dealing exclusively with these products. The increase of department stores was deplored and after the War the increase in 'self-service' supermarkets was likewise resisted. Only a few shops selling exclusively to the wealthier patrons, who were aware of the growth of interior design both as a concept and as a profession, sold tableware as part of an overall scheme. The potential of selling co-ordinated goods which could be selected individually but put together in identifiable styles was not generally recognized as a marketing strategy until the 60s.

Some retail concerns were based precisely on this concept. They set out to sell, to people who perhaps felt they did not have the confidence to choose for themselves, ranges of goods typifying certain standard alternatives. Terence Conran's chain of Habitat shops was one such retail operation. They started with designs originally made for Habitat, some by Terence Conran, and then bought in, often from the third world, pieces which would co-ordinate with them.

Besides the retailers some manufacturers themselves extended their ranges. In the amalgamations of the late 50s and early 60s, firms were either drawn into groups and found themselves producing the ceramic elements of a co-ordinated range of household furnishings or, if they had the capital and confidence, they could diversify by entering into the manufacture of other domestic goods. Two examples of firms which tried this policy with differing success and on different scales were the German firm of Rosenthal and Joseph Bourne Ltd of Denby.

In the 1950s Philip Rosenthal was, like most manufacturers of high quality tableware, very aware of the need to reconstruct the firm after the War and to re-enter the American

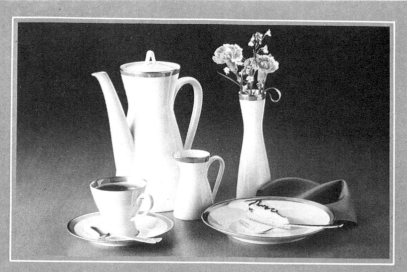

market which it had lost. Realizing that the market in America was not just for traditional high-priced ware but also showed a growing interest in modern design, Rosenthal started 'Studio Line'. To launch the range he chose to commission industrial designers with existing reputations and some knowledge of American conditions. Raymond Loewy and Walter Gropius, then living in America, designed ranges for him – 'Form 2000' and 'The Gropius Service' respectively. This Studio concept was extended in the 60s to the production of limited editions of art objects. Artists including Henry Moore, Eduardo Paolozzi, Vicktor Vasarely etc. were interested in the possibility of extending their activities into functional objects or limited editions which might reach a wider public. The graphic imagery of Vasarely and Paolozzi, though different in kind, was symptomatic of, and a suitable response to, the demand for surface design.

The inclusion of both glass and metalware in the range followed the acquisition of firms producing in other materials than ceramics. The logical extension of this was to include furniture also, thus offering a co-ordinated range to the market.

'Form 2000', 1984, one of Rosenthal's Classic Rose series of revived shapes from the 1950s.

The professed policy was to aim at the luxury market and Rosenthal has Studio line outlets of its own, selling direct to the public.

Rosenthal overcame the danger of being over-extended when the severe problems of the late 1970s struck. Other firms who attempted similar diversification were not so fortunate. The tremendous increase in the demand for stoneware tempted Joseph Bourne Ltd to extend their range to furniture and co-ordinated accessories. The furniture was produced in America while a range of porcelain to complement their own stoneware was manufactured in Portugal. The problem for Denby, and one which proved very difficult to overcome, was their strong identification with a particular brand image – that of stoneware.

One of the most noticeable features of pottery output from the late 50s to the early 70s is the very steep rise in the proportion of stoneware being produced. By the early 70s it was evident that this was not unique to Britain but was also true of other parts of the world. 'Stoneware' is a rather loose term which can be used to describe those vitrified bodies which are neither true porcelains nor bone-china. The arguments about the precise definition are not worth elaborating here. Stonewares were made in Britain in the 17th century in London, where John Dwight took the imported German forms and improved the composition and glazes. Potters in Staffordhsire, Derbyshire and Nottingham also developed the making of red stoneware and the technique of salt-glazing, but the competition from tin-glazed earthenware and porcelain in London lessened demand. When creamware was made into a major production by Josiah Wedgwood and others, it virtually killed the use of stoneware among polite society. The latter continued as a purely utilitarian ware, used for cooking pans, storage jars, drain pipes etc. Doulton's fortunes were based on the remains of the London trade. The production in Derby and Nottingham continued long enough to see a major revival in the 1960s. It was a trade of the 'out-potteries' not of Stoke itself.

Stoneware as a body was also increasingly used by Studio potters throughout the 20th century. The techniques of high-fired bodies and glazes as seen in oriental ceramics had acted as a major challenge to the French and the Americans and subsequently the British. By the 60s stoneware was seen in the public's mind as the medium of hand-crafted pottery. The growing informality of meal-taking, the concern over storage space and an interest in continental cooking had increased demand for pots which could combine cooking and serving. At first this was mainly confined to the middle class households who had the means to take holidays abroad and become expert in foreign food. Gradually, however, through the 60s people's awareness of the material concerns of advertising, their concern over the environment and a reaction to urban living prompted a swing against packaged foods and instant cooking, replacing them with a nostalgic interest in ruralism and alternative cultures. This not only enhanced the practical demand for traditional cooking ware but, more importantly, it dictated the 'image' which was required.

Three sources existed – plain glazed cooking ware such as had been produced by Denby and Pearson of Chesterfield for many years, much of it designed well before the War; studio pottery, expensive and often without the standard of reliability required; or imported stoneware. In this last, the Finnish firm of Oy Wartsila Ab, known universally as Arabia, beginning to export to Britain in the early 60s, had considerable success.

Arabia was founded in 1873 as the Finnish subsidiary of Sweden's Rorstrand company. It became independent in 1916 and merged with the Warlsila Group in 1947. It first produced bone-china using British techniques but changed to making porcelain in 1923. After the Second World War, as with most countries, export orders were at a premium and

the decision was made to produce modern ware suited to the lifestyles of the 1950s. The first oven-to-table range which was dishwasher proof was called 'Kilta'. In 1957, after years of research, a flameproof body was produced and used for 'Liekki' flameware. The practice (common in Scandinavian factories) of having research studios producing individual experimental ware within the industrial complex helped to preserve some of the image of hand-craftsmanship. 'Ruska' showed this clearly and was one of their most successful lines during the 1960s. This was also a period of rationalization. In 1957 there were 10,000 lines available, by 1971 this had been cut to 3,000. With the grow-

ing fight back by other firms, however, Arabia's lead in this market was gradually lost and by 1976 they were having problems and the tableware section was re-merged with Rorstrand.

Perhaps one of the obvious candidates to recognize the potential of this social trend was Joseph Bourne Ltd (Denby). Their original pre-war lines had been called such names as 'Cottage Blue', 'Manor Green' and 'Homestead Brown' emphasizing their rural traditions. Most of Denby's ware was still hand-thrown and then finished and glazed. These unmechanized processes were valuable advertising points. Denby continued its basic ranges while adding

some designed to sell to a higher income bracket and appealing to an apparently more sophisticated market by their allusions to French

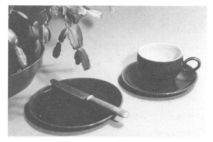

'Cottage Blue' stoneware by Joseph Bourne of Denby in production from the 1930s to the present.

Below: Gourmet award winning oven-to-tableware by Joseph Bourne, Denby Ltd, 1976.

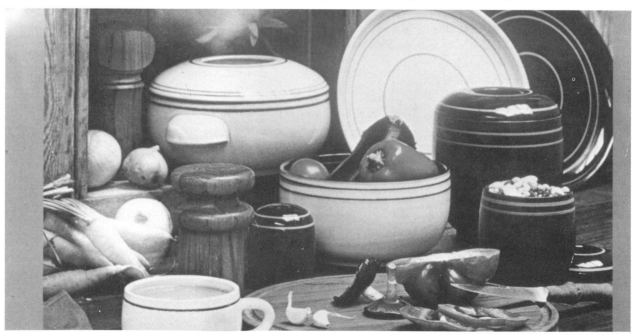

provincial cooking. Speckled colour and simulated textures were used to emphasize links with hand-made ware.

In 1973, Pearsons of Chesterfield announced that they too were rather belatedly making new efforts in this direction. They had become convinced by that time that there was an international level of acceptance for the basic product. They had the technology for high-fired stoneware and having produced ovenware now looked for a design for tableware. This was supplied by Jack Dadd who designed 34 items for the range.

It was important that this demand was seen to exist not just in Britain but in other countries too, particularly America. According to an article in the *Wall Street Journal* in June 1974, sales of oven-to-tableware in the United States had increased by 40 per cent in the previous 12 months, much of it imported.

The larger companies such as Doulton also put an emphasis on oven-to-tableware. Doulton produced their 'Lambeth' range as a deliberate reference to the stoneware used at the Art Pottery where the firm began. Worcester Royal Porcelain used their re-introduced high-fired

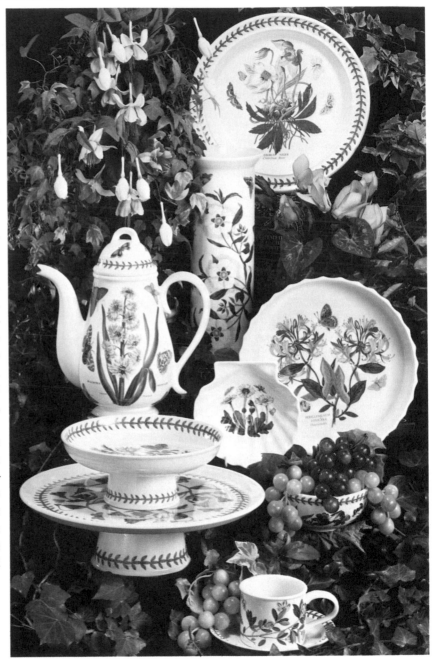

Oven-to-tableware by Susan Williams Ellis who took over A.E. Gray & Co. Ltd in 1962, renamed Portmeirion Potteries Ltd.

porcelain as an ideal material to combine both the heat-resisting capacities required in such pieces with a suitable elegance for the table.

The identification of the stoneware oven-to-tableware ranges with the craft image began to spin off into the earthenware lines being designed, though it had less obvious direct connection. In 1972, Tableware International described Midwinter's new 'Stonehenge' design as having the 'Stoneware look' and commented that this was good because both shape and decoration were relevant to the modern table and to the mood of the moment. Roy Midwinter and his wife Eve, designed 'Stonehenge' and it was, they claimed, *"intended for the casual living approach and accordingly has a studio-style appearance in shape, colour and decoration."*

'Stonehenge' sold very well, especially in America, but the fact that the superficial aspects of stoneware had been incorporated into an earthenware design was recognized. When in the mid-70s, Midwinter, now the Design Director of the earthenware division of Wedgwood, was introducing a new shape, he proposed that this new line should actually be made in stoneware. To further the craft

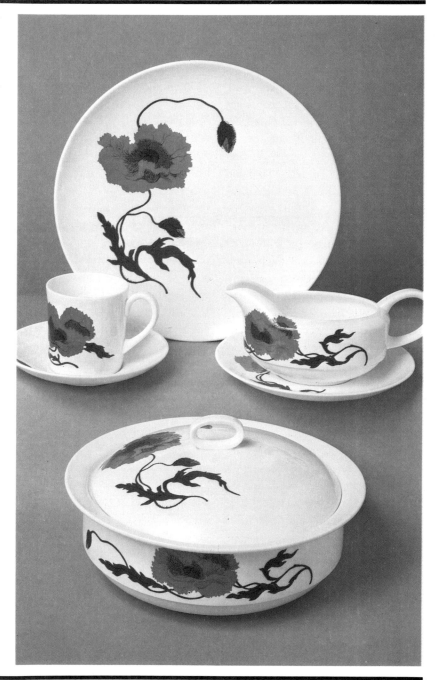

Susie Cooper's design 'Corn Poppy' in bone china introduced by Wedgwood in 1971 on 'Can' shape.

image he brought in Robin Welsh, a studio potter and designer, to work on the range.

Already by then these strong links with the image of studio pottery were changing. The oil crisis not only caused acute problems for the firms themselves but uncertainty about prices and inflation changed the pattern of demand. For that younger, middle income market, the rural escapism of the late 60s and early 70s was no actual protection from reality and the trend swung back towards urban sophistication. The micro-chip revolution and reaction to the sentiment of rural and revival styles led to an interest in quite specifically and overtly industrially produced objects. Studio pottery itself suffered as money became tight and spending on tableware declined. Such demand as there was came from the top end of the market, who seem increasingly to have felt the need for an image identified with elegance and connoiseurship.

While the British stoneware manufacturers could quite successfully supply the traditional, rural image, it was more difficult for the high priced earthenware makers, who had more competition, to accommodate the urban-sophisticate image.

One answer was to retreat still further into the making of expensive, traditional designs with border patterns using restrained floral motifs and high-quality gilding etc. The mood for deliberate formal elegance favoured those firms still trading on their long reputations for high-quality china. Other firms tried to define the demand in terms of new designs, believing that what was needed was a rather self-conscious elegance shown in the exaggeration of forms – a concentration on shape, with decoration either kept to a minimum (evoking the precepts of early modernism), or conversely highly dramatic. They produced very bright, elaborate designs on earthenware or they used rich colours, including black, with gold for china and porcelain.

Continental makers had the advantage that their wares already had a reputation for sophistication, and their success in importing into Britain was aided when Britain joined the European Economic Community. The industry's only previous interest in the work of other European countries had been with a view to assessing the competition in overseas markets, and it was new to have to see them as contenders in the home market. There had been interest in Italian design, for example, since the late 50s with regard to such products as furniture, mensware, shoes and, of course, the Scooter, but concern with Italian ceramic design did not begin until after Britain's entry to the E.E.C.

The Italian ceramic industry made a conscious drive to market goods to Britain in the early 70s. By far the largest producer in Italy was Richard-Ginori Societa Ceramica Italiana which developed from a small privately owned porcelain works in Doccia, founded in 1735, into a multi-factory operation by 1970. It was then producing traditional works based on original 18th-century designs, commercial lines in earthenware and porcelain and a speculative modern range called 'Prospettive'. Outside designers were employed for this range, particularly some of the industrial designers who had mainly come from an educational background in architecture.

Besides Ginori there were in 1974 over 200 ceramic firms in Italy, many of them still very small but an increasing number were being represented at trade fairs in an effort to gain entry into the British market. Earthenware, glazed opaque white in the tradition of faience and decorated with coloured lines or bands, was being produced very cheaply and blended well with the greater simplicity and lighter colours being favoured for informal dining. Habitat began to include them in their co-ordinated ranges.

Apart from these, Ginori's 'Prospettive' range and those of firms like Arte Ceramica Romana were highly styled. Some were essentially functional like Gariboldi's 'Eco' line for Ginori. Others concentrated on apparent individualism in design with

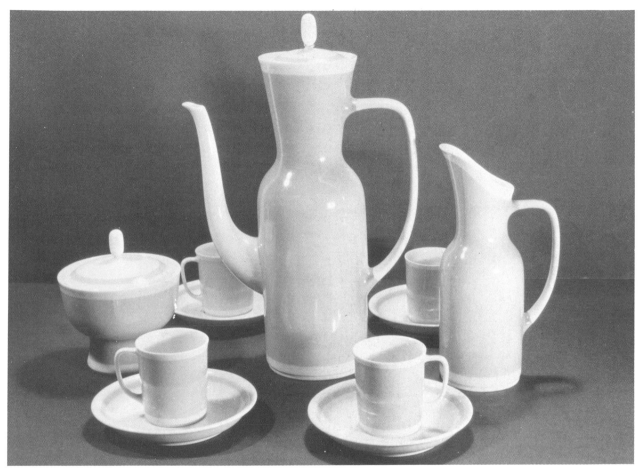

Coffee set in porcelain designed by Giovanni Gariboldi for Richard Ginori, c.1954.

conscious references to theories of form, for example Peter Chinni's 'Hexagon' dish set and the 'Cubicon' collection both for Arte Ceramica Romana. But the Italian economy was severely depressed and even the large firms suffered. In 1974 Ginori's was saved from bankruptcy by a take-over by Liquigas, who owned Ceramica Pozzi. The attempt to break into the British market has been more successful in the earthenware than the high-style lines. Such Italian design is of interest to designers and critics, but not, as yet, to most consumers.

Another firm which has notice-ably increased its sales in Britain in the high-priced earthenware market is Villeroy and Boch. This firm was one of the earliest 'multi-nationals' in the industry. Having been first estab-lished in Lorraine in 1748, the com-pany changed nationality as often as the region. It began by producing porcelain, but with the setting up of a new factory at Septfontaines in Luxembourg in 1767, the Boch brothers realized that it would be more profitable to reach a wider mar-

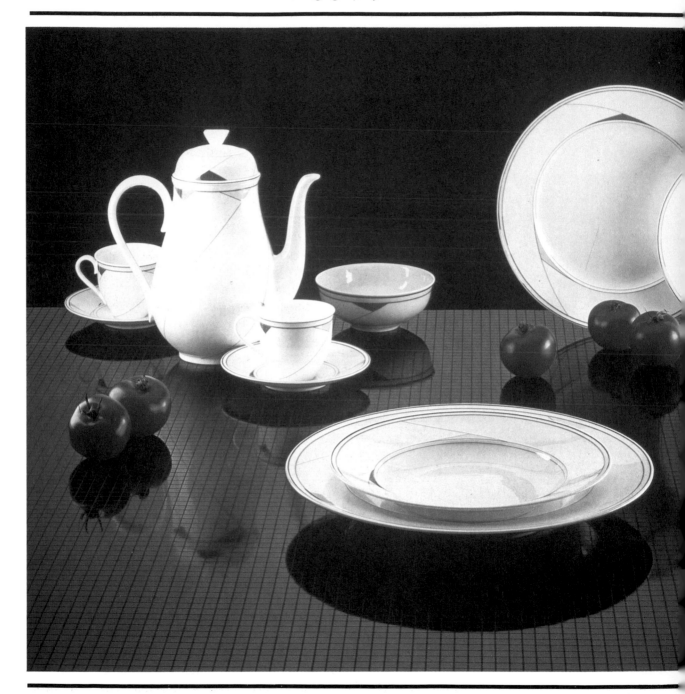

Contemporary dinnerservice – 'Trio' – produced by Villeroy and Boch, 1984.

ket with good quality earthenware aimed at the growing middle classes of the Industrial Revolution. The French Revolution nearly caused the firm to fold, but it survived to acquire a firm in Mettlach in 1809, thus opening up the German market. In 1836 Boch merged with another potter, Villeroy becoming Villeroy and Boch.

Like later multi-nationals, the firm moved its activities and attention between the works in different countries as tariffs or exchange rates favoured trade. The semi-mechanical processes of under-glaze transfer printing and an additional china-type body were adopted from England. As early as 1843 a crystal glass house was added to the company's range, and art stoneware was produced from the 1880s inspired by Sèvres and Doulton. The bulk of its mass-produced lines until 1945 were hand-coloured under-glaze prints. It had a unique base from which to supply a large market in Europe, besides which it exported to America. In the post-war period types of ware with bright, single-coloured glazes were produced for the United States market. These were developed after careful research into glazes which would comply with the increasingly stringent standards being set for chemical emission from tableware.

This problem was one which all companies had to face, particularly if they wished to export to the States where increasing concern with the pollution of food has resulted in new regulations to control not only the lead content of glazes but also cadmium and other metals. The dangers of using lead in glazes was recognized as early as the 18th century, mainly for the workforce not the consumer. Wedgwood had made experiments with leadless glazes, but its continued use was a perpetual subject of conflict between unions and management up until 1950. It was only then, on the introduction of the Pottery (Health and Welfare) Regulations, that its use finally ceased. One of the reasons for the Union's support of modernization of the industry in 1946 was that greater responsibility for health standards would be imposed on manufacturers.

This elimination of lead was followed however, by the realization throughout the 60s and 70s that lead was not the only danger and it was not only the workers at risk. Other metal oxides posed a problem to health and on-glaze decoration and certain colours of ware, particularly cadmium red, could react with acid food and release harmful elements. As a result the use of in-glaze treatments increased and a great deal of research was carried out into alternative glaze compositions.

THE STATE OF THE ART

ASSESSING what has been happening to design in very recent years is difficult and probably dangerous. It can only be a very speculative exercise, but it may be of interest to look back on in future years when we have the benefit of hindsight.

Three possibly related aspects will be dealt with here: the growth of multi-national firms operating across cultural and political boundaries; the increase in the use of professional designers and consultants; and an emphasis on complexity of form.

Taking the first to begin with, the trend that began to emerge in the 60s and early 70s has markedly increased in recent years. The industrialized countries have all experienced the recession of post-1979 but to differing degrees. Japan, for example, has maintained a relatively strong industrial base, but in consequence has been faced with threats of import restrictions by others. Organizations such as the E.E.C. favour movements of

goods between member countries, but restrict those from outside. In order to avoid these restrictions, large companies needing to extend their markets have acquired smaller firms (which have sometimes experienced difficulties because of the economic circumstances), within the country into which they wish to expand. By establishing subsidiary production companies they can be 'home market' producers. While they thus avoid import duties, the goods may be subject to Value Added Tax, but in this they are competing on equal terms with other firms. The benefits of this strategy are set against the various costs of resources and labour. Another major factor in the growth of multi-nationals is the exploitation of cheap labour in developing countries.

Noritake, the largest Japanese porcelain producing company has undertaken its expansion policies with both these advantages in mind. The parent company employs over

3,000 (almost all women) at its main factory on Honshu. Unlike many Japanese firms it integrates preparation, making and decorating processes. The smaller firms either concentrate on making whiteware or on decorating, often using outworkers. Noritake has consistently exported to America since 1904 when it was founded and established subsidiary companies for sales purposes overseas. Since 1970 the policy has been to diversify production as well as distribution by acquiring firms abroad.

Jepcor in America was founded in 1972 expressly to supply the growing market there for oven-to-tableware and co-ordinated accessories for informal dining. It caught the trend for gourmet home-cooking as a social event. The production of this company's ware was shared between Homer Laughlin in W.Virginia and Haeng Nam in South Korea who produced only for Jepcor, giving them the advantages of cheaper labour costs

than those in America. Metalware from Spain was also added. In 1975 Noritake realized the potential market for stoneware and established Nitto International Inc. to distribute casual stoneware. In 1978 it went further and became a major shareholder in Jepcor. With Noritake's backing, Jepcor has been able to carry out considerable technical research extending the making facilities in Korea.

Jepcor had employed an American design group, China Seas Design Associates. The team included Helen Uglow (a British designer who had done work for Wedgwood) and it had the experience to design a complete oven-to-table range, an approach already more established in Europe. Helen Uglow continued to design for Jepcor, but with the involvement of Noritake, Tsutsui of the Japanese firm became the resident designer. Before working in America he had been at Noritake's recently purchased Arklow factory in Ireland. Noritake had acquired the Arklow Pottery because Ireland was in the E.E.C. and could therefore enter the European market as a home producer. A factory in Sri Lanka was also established to supplement Japanese production and to ease distribution to areas between Japan and Ireland.

What were the implications for design interest in these complicated new sets of relationships in production? The answer is that there has been a growing tendency to see designs not as specifically belonging to one country or to a particular visual culture but as commodities on a world market which cannot afford to adapt ranges to suit national tastes. The specific qualities that make a design attractive to a particular market are expressed in the way it is presented in advertising and selling contexts. They are not actually embodied in the product itself. Its design has to be adaptable to different interpretations. This in a way could be seen as a truly 'International Style' brought about not by design polemics but by political economy. The results are somewhat similar – no specific or overtly national references, an emphasis on texture and colour rather than complex pictorial forms, and the choice of decorative sources limited to culturally neutral subjects such as nature.

British ventures into multinationalism are strictly limited. Wedgwood, one of the few firms to have maintained a full subsidiary company for the purposes of marketing in America from the 1920s, diversified its production by acquiring other British firms serving different areas of the market and also producing glassware etc., but not until recently did they appear to be making a move to obtain production facilities elsewhere.

The firm of Gladding, McBean & Co. expanded into the dinnerware market just before the War as part of the growth of potteries in California. Initially the firm concentrated successfully on bright, single colour ware and under-glaze, hand-painting based on Mexican-cum-Early American designs, called 'Fransiscan'. It continued to produce lines based on these sources, the one which proved particularly stable being 'Dessert Rose'. But by the late 60s and early 70s demand dropped for these now traditional designs and a new impetus was needed as the company was declining. In 1962, Gladding McBean had been purchased by the Interpace Corporation which was based on pipe and tile making, and in 1969 Interpace added to its holdings by purchasing Myott's in Stoke.

Fransiscan – as Gladding McBean became known – began producing more up-to-date lines designed to appeal to less traditional markets. 'Calypso' was a new hand-painted design while 'Kaleidoscope' was a response to the 30s revival and was very reminiscent of Rhead's Fiesta ware with altered colours. (The brilliant red of the original was one of the most difficult to produce in accordance with the cadmium emmission standards.)

Adaptations of these American designs then began to be produced for the British market at Myott's in Stoke. This also gave access to

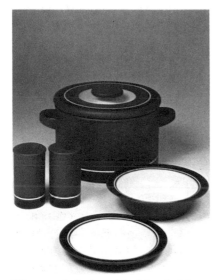

'*Contrast*', *designed by Martin Hunt for Hornsea Pottery Co. Ltd, 1975.*

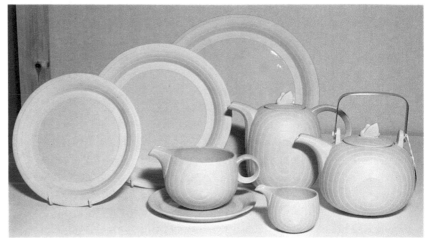

'*Concept*' *shape designed by Martin Hunt for Hornsea Pottery Co. Ltd.*

Europe. The patterns remained the same with most of the glazes and colours being imported. The methods of firing the in-glaze decoration to give the ware its particular effect was then claimed to be unique in Britain. The previous Myott range continued to be made, as Fransiscan was at the upper end of the earthenware price range. In 1979 Wedgwood announced that it was purchasing the American company from Interpace and forming a new company to run it, thus gaining their first production facilities there. But this move came just before the worst of the recession and the demand for higher priced earthenware was uncertain in both America and Britain. Even such a well estab-

lished firm as Wedgwood felt the effects and recently the announcement was made that the Los Angeles factory might be closed altogether.

This awareness of the international nature of the markets now sought, together with the multinational structure of some production companies, is leading to an increasing use of freelance designers or consultants. It is growing more common to use designers based in the country of destination of the goods, rather than the country of origin. So designers with knowledge of consumer demand and trends may nowadays have to make visits to the place where the production is based, whereas formerly they were based at the factory and periodically allowed to leave on trips abroad.

The use of professional industrial designers emerged in America in the 30s and is still perhaps more common

there than elsewhere, but other countries are following suit. In Britain there is still the tendency to assume that a production company should be based on the actual factory or works making the ware. The emphasis is on invention or innovation and its subsequent production. In America, companies such as Jepcor quoted above, are sales led – a possible gap or underexploited section in the market is identified and then the product designed to fill it. Only when the idea has been put forward and approved is the factory found or established to produce it. Looking at the sequence of events that way round, it makes sense to employ a freelance design firm who can think across a range of products and 'media' and who can show that they understand the

market and possible sales.

Firms that are production based are more likely to favour specifically trained designers who fully understand production problems and can work closely with the factory. This is largely the case with the larger and older firms, though obviously companies like Wedgwood and Rosenthal will sometimes invite outside designers or artists to produce special designs.

The awareness that more interesting and possibly more lucrative work can be done from the consultancy position has encouraged designers to establish their own businesses. Some of those who were making experiments in the early 60s are now well established in such positions.

The Queensberry-Hunt partnership typifies this process. David Queensberry is reported to have first become interested in porcelain at Eton and then during his studies at Art School. After carrying out some designs for Crown Staffordshire he worked with Roy Midwinter on designs for Midwinter's 'Fine' shape and himself designed one of the most successful shapes produced before the merger with Meakin in 1968 called 'Queensberry'. He had been appointed Professor at the Royal Col-

'225' designed by Jerome Gould in bone china and black basalt to mark the anniversary of Wedgwood, 1983.

lege of Art in 1958. In 1968 he set up a partnership with Martin Hunt as consultants/designers.

Martin Hunt studied for the National Diploma in Design at Cheltenham. He studied pottery but it was not until he gained a place at the Royal College under Queensberry that he learnt any industrial techniques. He became particularly interested in model-making, an area where pre-war skills were being lost as the emphasis was on decoration and reduced numbers of shapes. He has stated that, *"the design of the sixties was undemanding of model-making skill, and consequently industry lost some of the arts. It seemed obvious to me that if I was to control the quality of my designs I would have,*

in most cases, to make the master-models myself."

In spite of doing ceramics he nearly decided to become a more general product designer but Meakin invited him to design some tableware and Queensberry suggested that they form the design partnership. He also won a competition organized by Rosenthal taking him to factories in Germany. The partnership has worked for a large number of companies in both Europe and Britain.

As well as Rosenthal, Hunt worked for Bing and Grondahl in Denmark and particularly for Hornsea in Britain. Queensberry, while remaining at the Royal College, acted as a consultant for the Allied English Potteries/Doulton group and as a

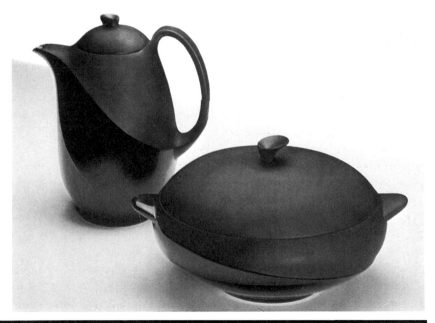

member of the consultant panel for the Rosenthal Studio line. In the early 70s a small number of young designers were added to the group.

In 1978 this team collaborated on producing a range for Enoch Wedgwood of Tunstall called 'Marquess'. It showed that smaller firms in the Potteries were prepared to use outside design firms. This line was in earthenware combining a modern thin-rimmed semi-coupe shape with more traditional broadly fluted holloware. The patterns were designed by Hazel Canning, a textile designer who had joined the group as a surface pattern designer. The shape was largely a collaboration between Robin Levien and David Queensberry.

More recent work includes 'Trend' for Thomas, a subsidiary of Rosenthal with factories in Waldershof, Kulm and the Republic of Ireland. Queensberry described the designing of 'Trend' in an interview with *China, Glass and Tableware* in 1983: "*We started designing Trend at what might be called the end, namely with potential menus.*" They studied types of cooking, ways of entertaining all the possibilities of preparation and serving. The line was designed to fit in with a more informal way of life especially among the young. They designed so-called 'core' pieces and then satellite collections to meet the needs of different kinds of cooking and serving. The emphasis claimed

for this project was on functional shapes specifically and not on high fashion. 'Queensberry Marble' for the Rosenthal Studio Line is rather different. The marbling technique in the clays makes each piece unique – similar to the old agate ware – and they are sold as one-off ornamental pieces. The group also designs a lot of work for Terence Conran's Habitat shops. Besides being commissioned by specific companies they act as entrepreneurs in perceiving a need or opportunity, designing to meet it and then finding the sales outlet and manufacturing techniques.

The emphasis Martin Hunt puts on shape is perhaps most clearly seen in his work for Hornsea Pottery. Hornsea had some advantages for producing innovative shapes. It had been formed relatively recently in 1949 to cash in on the post-war boom with gift-ware, but, unlike many firms which spanned the decade of 1946-56, it did not disappear again with the trade depression of the late 1950s. Instead it moved into tableware production. It was ouside the Potteries and had relatively new and mechanized plant. The restrictions created by old working conditions and a long family history did not apply in this case. Effective design management was recognized as essential from the beginning of its tableware production. Their resident Design Director produced 'Heirloom'

in the late 60s using techniques of screen printing developed at Hornsea. In 1975 a new shape was designed by Martin Hunt and the surface patterns were added by the in-house team. This 'Contrast' line utilized texture as the major effect, glazed surfaces contrasting with matt polished ones. The shapes are basically cylindrical and have the explicit qualities of design for the machine. The later 'Concept' shape by Hunt is very different. The concentric circles and figurative teapot knob in the shape of a swan, all reflect a concern with more elaborately modelled shapes. It seems specifically to deny the 'logic' of factory-made ceramic shapes, and this eccentricity is made a positive feature. There was an awareness here that, despite the apparent reduction in purchasing power created by growing unemployment and high interest rates, there was still a major section of the consuming public which had money, and were prepared to pay quite high prices for something distinctive.

The trend is that more and more firms are trying to move their products 'up-market' into this more lucrative area, while at the bottom end of the market, suppliers survive by producing the minimal basics. This move into new market sections has prompted firms to employ designers to assist their success.

Cheap porcelain or bone china is

being produced to replace earthernware for casual crockery such as mugs. The appeal of porcelain is that, in Britain particularly, it is associated with very expensive continental dinnerware, while the qualities of whiteness, fine texture and thinness equate with the 'urban sophisticate' image rather than the country look. New companies arising from entrepreneurial activities in this area are Nicholas John in Milton Keynes and Dunoon Ceramics, both of them outside the more traditional pottery producing areas.

The tendency to sameness and neutrality engendered by the multinationals is being opposed by an emphasis on individualism, expressed by the designers in eccentricities of shape, sculptural embellishment and figurative references. Individualism is implied in the customer by allusion to exclusive designs, lack of concern with utilitarian function and the use of a more complex language of forms.

Examples of these are often commissioned from designers whose education took place post-60s which was not only when 'Pop Art' challenged the establishment criteria for judging 'good design' but when art education itself was re-organized to put a greater emphasis on individual creativity and 'Fine Art' in design. The work of Roger Mitchell and Danka Napiorkowska for Carlton is a case in point. Famous for their 'Walking Ware',

taken up and manufactured by Carlton, they have since produced pieces like the 'Fox Tureen' in 1978 – an expensive one-off purchase.

The recognition that a high percentage of ceramics are bought as gifts and that when money is tight, people will still continue to buy gifts rather than goods for themselves, has made manufacturers pursue this aspect of pottery, particularly in times of recession.

The increased emphasis on shape is seen not only in the newer production companies (though perhaps for them it is in some ways easier), but also in some of the most well-established. Several new shapes have been launched recently to re-kindle interest in a difficult market. The Wedgwood '225' shape, produced to celebrate its anniversary, is sculptural in form. Remarkably fluid with a continuous curve from spout-edge to handle, it evokes the asymmetry of Art Nouveau and, significantly, the more recent 1950s. In the black basalt version it makes an interesting contrast to the 18th century 'Queensware' shape still in production with its simplified more geometric forms so beloved by the modernists.

'Style' by Midwinter was introduced at the Birmingham trade fair in 1983. This also has interesting reminiscences of the 1950s. The flattened oval cross-section of the teapot and jugs etc., and the continuity be-

tween spout, body and handle give this too a plastic appearance. 'Bouquet', the most recent design by Hunt for Hornsea, also shows these characteristics, which were introduced, it was announced, in order to add 'a softer, more feminine shape to the Hornsea range'.

The conscious references to the woman as the purchaser of ceramics and the way that woman is characterized is interesting in other examples too. Karl Lagerfeld, a German designer living in Paris, produced 'Fleuron' for Hutschenruether – the German group including Arzburg and Tuschenreuth – who are big exporters to America. This design was also heavily promoted as having an emphasis on the feminine. The Calla lily, which is the symbol of the company marketing it, is worked into the design of the plates as an asymmetric border relief and it also crowns the footed cup where it flows continuously into the handle. The result of this sinuous organic motif is decidedly 'Art Nouveau' and the colouring of the patterns picking out the modelled lily against either black or white backgrounds enhances this.

The appeal to the 'feminine' home-maker and hostess in times of unemployment and depression has its precedents. In 1934 John de la Valette, organizer of the Royal Academy Exhibition of British Art in Industry expressed his dislike of the

China stone service 'Iris on Grey' currently in production – Lennox China Inc.

aims of international modernism and placed the responsibility for its rejection upon the female. 'Madam', he claimed, was weary of hospital-cum-factory furniture and it was to 'Madam' that they could look for salvation: *"She has so long been a woman – manly, sturdy and striving after something-or-other, and I believe she is about to be content once more with merely being a lady – with all the charm, distinction and the* taste *which that term connotes."* Is a similar belief being represented by these designs today?

The desire to find new shapes and patterns to express a swing away from the country craft preoccupation to a new urban consciousness has produced some solutions which seem to have a similarity to the early modernism of the Vienna seccessionists and the contemporary designs of the 50s, but in some cases this is, without doubt, deliberate. The interest that has recently been shown in the music, clothes and lifestyles of the 50s has led to conscious pastiche. Federated Potteries was formed through the amalgamation of two older potteries, Grindleys and Cartwright and Edwards in 1981. A new board was formed, many of whom came from other sections of industry and brought with them experience and sales techniques. Roy Midwinter is on the board and produced the first range of designs called the 'Designer Collection'. The link with fashion marketing was deliberate. These new designs included very dramatic surface patterns in bright colours such as 'Fireball', 'Safari' and 'Tropicana', all asymmetric prints on coupe-shape ware, the patterned flatware being teamed with coloured holloware, a format reminiscent of his own Stylecraft designs. Sandy Grant, the Marketing Director, explained optimistically: *"Stores are coming to realize that they cannot mass-merchandise in order to compete with supermarkets – what they have to sell is individuality not price, and that is where we come in."*

The effect of the recent recession on the industry in Britain has been the closure of some 37 factories since 1978 and hundreds of redundancies. The mass-manufacturing capacity, with its emphasis on standardized products and low prices, has not the

Advertisement for the 'Designer Collection' by Federated Potteries illustrated in Tableware International, *1984.*

flexibility to respond to the fashion-led areas of the market with their high turnover of design. In the 30s it was noted as an argument against mass-production that in times of slack trade the art department was at its busiest producing variations of design. It will be interesting to see if the current interest in the use of designers will continue if trade picks up. Even in America, where it could be argued the mass-production factory system first developed, there is evidence of a disillusionment with this type of goods and a desire for social differentiation in the guise of the personalized product. The editorial of *China, Glass and Tableware* in April 1985 was headlined 'Getting into the Spirit'. It began:

"Diversity, Pluralism. This may start out sounding like a political thesis, but the unmistakable truth is that this country (America) is built on diversity, with a certain individualistic spirit running through it. While mechanisation and mass-production have yielded the 'sameness' that only economics can justify, the population rebels in its own way to impart individual stamps upon those mass-produced goods."

Diversity, Individualism. It is not pure co-incidence that the values expressed by the Victorians of the 1880s are being invoked in the world of the 1980s.

BIBLIOGRAPHY

BERKOV, N. *Wallace-Homestead Guide to Fiesta* Wallace-Homestead Book Co., Iowa, 1978.

BRYAN, A. Changes in the Ceramic Tableware Industry in *Royal Society of Arts Journal* CXIX No. 5175, 1971.

CHANDLER, M. *Ceramics in the Modern World* Aldus, London, 1968.

CLARK, G. & HUGHTO, M. *A Century of Ceramics in the United States 1878-1978* E P Dutton & Co., New York, 1984.

COOPER, R.A., HARTLEY, K. & HARVEY, C.R.M. *The UK Pottery Industry Export Performance and Pressure of Demand* Allen & Unwin, London, 1970.

COUNCIL OF INDUSTRIAL DESIGN *Design '46. A Survey of British Design as Displayed in the 'Britain Can Make It' Exhibition* H.M.S.O., London, 1946

CUNNINGHAM, J. *Collectors Encyclopedia of American Dinnerware* Collectors Books, Kentucky, 1982.

FARR, M. *Design in British Industry: A mid-century survey* C.U.P., Cambridge, 1955.

FRENCH, N. *Industrial Ceramics: Tableware* O.U.P., Oxford, 1972.

GAY, P.W. & SMYTH, R.L. *The British Pottery Industry* London, 1974.

GEFFRYE MUSEUM *Utility Furniture: Exhibition Catalogue,* 1975.

GLOAG, J. *The English Tradition in Design.* Penguin, London, 1947.

GODDEN, G. *British Pottery* Barrie & Jenkins, London, 1974. *Encyclopedia of British Pottery & Porcelain marks* Bonanza Books, New York, 1964.

HEAL'S *Heal's Catalogue of Tableware,* 1934.

HILLIER, B. *Austerity Binge* Studio Vista, London, 1975.

HONEY, W.B. *The Art of the Potter* Faber & Faber, London, 1946.

KLEIN, B. *The Collectors Illustrated price guide to Russel Wright Dinnerware* Exposition Press, New York, 1981.

KOVELS ANTIQUES PRICE GUIDE *Depression Glass & American Dinnerware* Crown Publishers Inc, New York, 1980.

McCARTHY, F. *A History of British Design 1830-1970* Allen & Unwin, London, 1979.

NATIONAL SOCIETY OF POTTERY WORKERS *Reconstruction in the Pottery Industry* Co-operative printing Society Manchester, Manchester 1945.

PEVSNER, N. *An Inquiry into Industrial Art In England* C.U.P., Cambridge, 1937.

POTTERY AND GLASS TRADES BENEVOLENT SOCIETY *A Textbook for salespeople in the Pottery & Glass Trades* Scott Greenwood & Son, London, 1923.

PREAUD T. & GAUTHIER, S. *Ceramics in the 20th Century* Phaidon (Christie's), Oxford, 1982.

PULOS, A. *The American Design Ethic* M.I.T., 1983.

READ, H. *Art & Industry* Faber & Faber, London, 1934.

ROSENTHAL, E. *Pottery & Ceramics* Penguin, London, 1949.

SMYTH, R.L. & WEIGHTMAN, R.S. *The International Ceramic Tableware Industry* Croom Helm, London, 1984.

STILES, H. *Pottery in the United*

States E.P. Dutton & Co., New York, 1941.

THOMAS, J. *The Rise of the Staffordshire Potteries* Adams & Dart, 1971.

ZEISAL, E. *Eva Zeisal: Exhibition Catalogue* Le Chateau Dufresne, Montreal, 1984.

British Periodicals:

Pottery Gazette and Glass Trades Review
Pottery & Glass
Tableware International
Design
The Studio Decorative Arts
Yearbooks

American Periodicals:

Keramik Studio
Pottery & Glassware Reporter
Crockery & Glass Trades Journal
China, Glass & Tableware

GLOSSARY

Backstamp The maker's mark placed on the underside of a piece of ware giving information about manufacturer. Sometimes pattern name and designer also appear.

Ball-clay Plastic clay used as a component of most bodies.

Biscuit firing The first firing of the body before decorating or glazing.

Bottle kilns The older coal-fired intermittent kilns, the shape of which resembled a brick bottle.

Burnishing The polishing needed on high quality gilding after it is fired to bring up the shine.

China clay White clay from decomposed granite used in making porcelain and china bodies – also added to finer earthenware.

Coupe shape Refers to flatware with a continuous surface and no distinct rim, literally from the French 'cut'.

Creamware Earthenware body of a fine texture – cream coloured and developed in the 18th century.

Decal Short for decalcomania, the American name for ceramic transfers used for decoration, usually produced by lithography.

De-flocculating agents Chemicals added to slip clay which act on clay particles to allow it to liquify with less water.

Earthenware Ceramic body made from combinations of refined and porous clays requiring glazing to prevent absorption.

Flatware Plates, saucers, shallow dishes, etc.

Granite ware Name often used for type of hard, semi-vitrified earthenware, much of it made in, or exported to, the USA.

Hard paste Porcelain which requires high temperature firing for vitrification.

Holloware Deep dishes, cups, bowls, jugs, teapots, etc.

Intermittent kilns Static ovens which are loaded, heated to required firing temperature and then cooled to allow unpacking.

Jiggering Method of making plates and flatware by pressing bats of clay onto a plaster mould which forms the top surface of the piece. The back is formed by a profile lowered onto the clay as it turns.

Jolleying Similar to jiggering but used for holloware where the plaster mould forms the outside against which clay is pressed either by hand or profiled tools.

Litho Short for lithographic

transfer – British name for decal.

Lustre painting Decoration using oxides which when fired in a reducing or oxygen-starved atmosphere produce a metallic shiny appearance.

Majolica Originally tin-glazed earthenware decorated with on-glaze colours. In the 19th century used more loosely to describe earthenware decorated with very bright opaque glazes.

On-glaze painting Decoration carried out after the piece has been glazed, usually with low-fired enamel colours.

Open stock Ranges kept by retailers which could be bought as single pieces or any combination, not 'sets'.

Porcelain A white, high-fired, vitreous, translucent ceramic body.

Pressers wheels The wheels on which bats or thin slabs of clay were pressed against a mould to form dishes, plates, etc.

Slip Liquid clay mixed to a pouring consistency, to aid this de-flocculents may be added.

Slip-casting Making method involving pouring slip into a plaster mould which may be of many pieces. When a deposit has built up on the inside surface, the excess is poured off and the clay dried until it can be removed.

Soft-paste Porcelain containing some fluxing agent which allows it to vitrify at lower temperatures than hard-paste.

Tunnel kilns Continuously fired kiln where ware is loaded onto trolleys or cars which pass automatically through the firing chamber.

Under-glaze painting Decoration carried out on the biscuit fired ware with under-glaze colours before the covering transparent glaze is applied.

Whiteware Ware of a white body left glazed but undecorated.

B.I.I.A. British Institute of Industrial Art

B.P.M.F. British Pottery Manufacturers Federation

Co.I.D. Council of Industrial Design (later the Design Council)

D.I.A. Design and Industries Association

S.I.A. Society of Industrial Artists

ACKNOWLEDGEMENTS

The author and publishers would like to thank the following for their permission to reproduce the photographs on the pages listed: The Trustees of the British Museum: pages 20, 25, 56, 57; The Design Council: page 87 (right); AB Gustavsberg: pages title, 60, 61; Homer Laughlin China Co: page 70; Hornsea Pottery Co. Ltd: pages 102, 104; Keramik-Museum, Mettlach: page 44 (top); Lenox China: pages 43, 106; Midwinter: page 107; Minton Museum, Royal Doulton (UK) Ltd: pages 26, 35 (bottom), 52, 53; Portmeirion Potteries Ltd: page 94; Trustees of the Science Museum: pages 11, 32-3; The Studio: page 29; Tableware International: pages 13, 14, 22, 31, 35 (top), 36, 37, 38, 40, 42 (left and right), 44 (bottom), 46, 48, 50 (left), 54, 67, 69, 73, 81, 86, 91, 107; The Trustees of the Victoria and Albert Museum: pages 39, 54, 63; Villeroy & Boch for 'Trio' bone china available from Courtier shops throughout the country: pages 98-9, cover (UK edition); Josiah Wedgwood & Sons Ltd: pages 12, 13 (bottom), 88, 89, 95, 103; Wedgwood Museum, Barlaston, Staffs: pages 8, 13 (top), 87; Eva Zeisel: pages 80, 81. All other photographs were supplied by S. Bradford. The author would also like to thank all those who supplied pieces from their private collections and the libraries, galleries and museums consulted for their invaluable information and assistance.

WITHDRAWN

INDEX

Numbers in bold indicate illustrations.

Adams, John 29, 74
Adams, Truda 37, **39**
Allied English Potteries 103
American Ceramics Society 44
American Encaustic Tiling Co. 68
American Limoges 70
American Standards Association (A.S.A.) 38
Anning Bell, Prof. Robert 31, 35, 45
Arklow Pottery 101
Arte Ceramica Romana 96, 97
Artel 45
Arzberg 63, 105
Ashbee, C.R. 74
Ashtead Potters Ltd 74

Bach, Richard F. 68
Baker, Prof. R.W. 34, 79
Bauhaus, The 42, 52, 55
Berlin State Porcelain Factory 17, 25, 26
Bing and Grøndhal 103
Binns, Charles F. 28, 40
Bonnin & Morris 15
Bourne, Joseph & Sons Ltd (Denby) 76, 90, 92, 93, **93**
Brain, E & Co. Ltd 49, 52, 65, 78
Brangwyn, Frank 52, **53**
Branksome Ceramics Ltd 85
Breck, Joseph 43
British Insitute of Industrial Art (B.I.I.A.) 30, **31**, 54, 64
British Pottery Manufacturers Federation 33, 55, 72, 76
Brown, Barbara 89
Burton, Joseph 74

Canning, Hazel 104
Canning Pottery Co. Ltd 37, **38**
Carlton Ware Ltd, **83**, 105
Carter, Charles 29
Carter, Stabler & Adams Ltd (Poole Pottery) 29, 37, 64, 79
Casson, Hugh 83
Castleton China Co. 81
Ceramic Society, The (English) 30, 51, 58
Ceramica Pozzi 97
Cheney Bros. 44
Chermayeff, Serge 55, 57, 60, 64
Chewter, Pat 89
Chinni, Peter 97
Cliff, Clarice 47–9, **50, 51**, 53, 60, 90
Coates, Wells 55, 64
Cole, Henry 18, 19
Coleman, William 19
Columbus School of Ceramics 27
Conran, Terence 83, 90
Cooper, Susie 36, 60, **62**, 66, 78, **88**, 95
Copeland & Sons Ltd (Spode) **32**, **73**, 86, **87**
Council of Industrial Art 73
Council of Industrial Design (Design Council) 59, 73, 74, 76, 77, 78, 84, 88
Creange, Henry 43
Cripps, Richard, Stafford 74, 75, 78
Crown Staffordshire China Co. Ltd 87

Dadd, Jack 94
Dalton, Hugh 73
Dalton, W.B. 31, 45
Deck, Théodore 25

Design & Industries Association (D.I.A.) 29, 30, 36, 37, 46, 52, 74
Design Research Unit 74
Deutsche Werkbund 28, 29, 36, 41
Doat, Taxile 25
Doulton, Henry 21
Doulton & Co. Ltd 21, 49, 52, **52, 53**, 72, 78, 92, 94, 99
Dressler, Conrad 86
Dunoon Ceramics Ltd 105
Dwight, John 92

Eastlake, Charles 23
Everett, John 65

Farr, Michael 77, 78, 80
Federated Potteries 106, **107**
Festival of Britain 78
Festival Pattern Group 78
Fischer, Moritz 44
Flaxman, John 54
Forsyth, Gordon 31, 33, 48, 51, 57, 69
French, Neal 86, 87, **87**
Friedlander, Marguerite 56, **57**
Fry, Roger 60

German Standards Commission 38
Gladding, McBean & Co. 69, 101
Government Schools, S. Kensington 19, 27, 33
Gray, A.E. 31, 35, 60, 64
Green T.G., & Co. Ltd 63, **63, 64**
Gropius, Walter 55, 91
Guimard, Hector 25
Gustavsburg Ab. **title page**, 58, 59, **60, 61**, 82

Hallcraft 82
Harker Pottery Co. 68
Harrods Ltd 53
Heal & Sons Ltd 29, 35, 36, **36**, 37, 46, 90
Herend 44
Hill, Oliver 45
Holmes, Frank G. 43, **43**, 44
Homer Laughlin China Co. 16, 67, **67**, 68, 69, **70**, 81, 100
Honey, W.B. 76
Hornsea Pottery Co. Ltd 102, 104, 105
Hunt, Martin **102**, 103, 104, 105
Hutschenreuther Co. 105

Iroquois China Co. 68

Jahn, Louis 19
Jepcor Inc. 100, 102
Jersey Porcelain & Earthenware Co. 15
John, Nicholas, Ltd 105
Johnson Bros (Hanley) Ltd 44
Jones, George & Sons Ltd 36, 46

Kåge, Wilhelm **title page**, 59, 60, **60, 61**, 82
Knight, Dame Laura 65

Lagerfeld, Karl 105
Lattie, M.J. 70
Lenox Inc. 15, **43**, 44, **106**
Lessore, Emile 19
Levien, Robin 104
Liberty, Arthur 21
Lindberg, Stig 82
Lindig, Otto 56
Loewy, Raymond 83, 91

Marks, Gerhard 56
McLoughlin, Mary Louise 24

Meakin, J. & G., Ltd 87
Meissen 10, 16-7, 19, 25
Mellor, Prof. D. 55
Metropolitan Museum of
 Art, N.Y. 40, 41, 43
Meyer, Hannes 56
Midwinter, Roy 81, **82**, 83,
 84, 87, 95, 103, 106
Midwinter, W.R. Ltd 79, 105
Minton's Ltd 17, 18, 19, 21,
 26, 35, 46, 47, 49, 68, 72
Minton, Herbert 18
Mitchell, Roger 105
Moorcroft, William 63, **66**,
 76, 78
Moore, Bernard 55
Moore, Edward C., Jnr 43
Moore, Henry 91
Morgan, William de 19
Morris, William 18, 19, 23,
 24, 57, 89
Moser, Koloman 44
Murray, Keith 62, **63**, **64**,
 65, 76
Muthesius, Hermann 29

Napiorkowska, Danka 105
Newark Museum, N.J. 41
Newcomb Pottery, The 43
Newport Pottery Co. Ltd
 48, 50
Noke, C.J. 42, **53**
Noritake Co. **86**, 100, 101

Odelburg, A.S.W. 58
Olbrich, J.M. 25, **44**
Onandaga Pottery Co. 16

Paden City Pottery Co. 68
Paolozzi, Eduardo 91
Pearsons & Co. Ltd 92, 94
Pevsner, Nikolaus 53, 54,
 62, 63, 74, 76
Pick, Frank 52, 73
Pilkington's Tile & Pottery
 Co. Ltd 31, 74
Plant, R.H. & S.L., Ltd 78
Porzellan-Manufaktur,
 Joseph Böck 44, **44**
Potters Union, The 72, 75, 99
Pritchard, Jack 55
Procter, Ernest 65

Quant, Mary 89
Queensberry, David,

Marquis of 87, 103, 104

Ravilious, Eric 54, **54**, **55**,
 62, 76
Read, Herbert 62, 63, 74, 76
Red Wing Pottery Co. 81
Rhead, Frederick A. 49, 68
Rhead, Frederick H. 68, 69,
 81, 101
Rhead Pottery, The 68
Richard-Ginori Societa
 Ceramica Italiana 96, **97**
Richards, Charles R. 43
Ridgway Potteries Ltd **83**, 84
Robineau, Adelaide Alsop
 24, 25, 26
Rookwood Pottery 24
Rörstrand Ab 59, **82**, 92, 93
Rosenthal, Philip 90
Rosenthal, Philipp 25
Rosenthal AG 90, **91**, 92, 103
Royal College of Art 34, 79, 86,
 89, 103
Royal Copenhagen Porce-
 lain Co. 59
Ruskin, John 18, 23, 35, 57, 74
Russell, Gordon 73, 74

Sadler & Green 12
Sandersons Ltd 90
Schmuz-Baudiss, Theordor 25
Schramberg Pottery 80
Schreckengost, Victor 70
Sebring Brothers 16
Sebring Potteries 70
Sèvres 10, 17, 19, 25, 99
Sheerer, Mary S. 43
Shelley Potteries Ltd 50, 90
Shelley, Percy 50
Shorter, Arthur 47
Shorter, Colley 48
Skeaping, John 54
Slater, John 49
Slater, Walter 49
Society of Industrial Artists
 (S.I.A.) 51, 54, 57, 60, 64
Solon, Marc 68
Sparkes, John 21
Spode, Josiah 9, 10
Stabler, Harold 29, 37
Staffordshire Potteries Ltd 89
Staite Murray, William 34
Sterling China Co. 68
Steubenville Pottery 67
Stevens, Alfred 19

Stevenson, H.G. Ltd 35
Styles, Helen 77
Summerley, Felix 18
Svenska Slöidforeningen 58, 59
Syracuse China 16

Tait, Jessie **79**, 83, 84
Taylor, Smith & Taylor Inc.
 67, 69
Teague, Walter Dorwin 67
Thomas China 10
Thorogood, Stanley 30
Tiffany & Co. 43
Trenton School of Ceramics
 27, 28
Trethowan, Harry 29, 35,
 36, **36**, 37, 46, 90
Tucker Porcelain Co. 15
Turner, John 10

Uglow, Helen 101

Valette, John de la 65, 105
Vasareley, Victor 91
Vernon Kilns **69**, 69
Vienna State Porcelain
 Factory 17, 44
Villeroy & Boch **44**, 97, 98, 99
Vincennes 10
Vitrified China Manufac-
 turers Association 38

Wagenfeld, Wilhelm 56, **56**
Waring & Gillow Ltd 35
Wärtsilä Ab Arabia 92
Weaver, Sir Lawrence 74
Wedgwood, Enoch 104
Wedgwood, Josiah 9, 10, 12,
 13, 54, 62, 65, 92, 99
Wedgwood, Josiah & Sons
 Ltd **8**, **12**, **13**, 17, 36, 46,
 49, **54**, 63, **64**, 65, 67, 68, 72,
 75, 76, 78, 79, 87, **87**, **88**,
 89, 95, 101, 102, **103**, 105
Welch, Robin 96
Wennerberg, Gunnar 58
Whistler, Rex 54, **54**
White, David 86, 87, **87**
Wiener Werkstätten 44, 45
Wild, Thos C. & Sons Ltd 89
Wileman & Co. Ltd 49
Wilkinson, A.J. & Sons Ltd
 47, 49, 53, 65
Wood & Sons Ltd 68, **82**
Worcester Royal Porcelain

Co. Ltd. 12, 21, **23**, 28,
 46, **46**, 49, 51, 78, 87, 94
Wright, Russel 67, 68, 80, 83

Zeisel, Eva 80, **80**, 81, **81**,
 82, 83